NATIONAL GEOGRAPHIC

NATIONAL GEOGRAPHIC

THE SCIENCE BEHIND THE SAGA

AMY BRIGGS ★ FOREWORD BY PETER VESTERBACKA

NATIONAL
GEOGRAPHIC

Washington, D.C.

To Crenshaw, for being the scoundrel in my life

Published by the National Geographic Society, 1145 17th Street N.W., Washington, D.C. 20036

Paperback ISBN: 978-1-4262-1302-1 Hardcover ISBN: 978-1-4262-1303-8

Book design by Jonathan Halling
Printed in the United States of America
13/QGT-CML/1

Contents

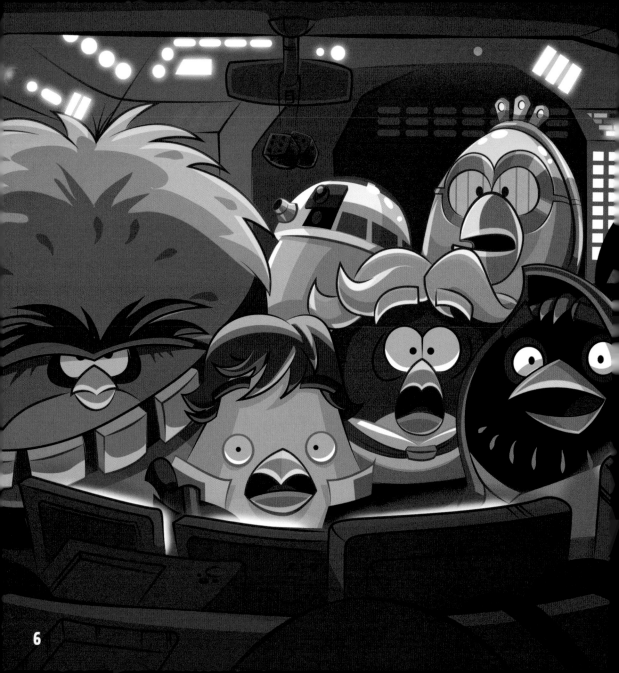

MAY THE BIRDS BE WITH YOU!

Star Wars has captivated audiences for decades, and as a huge fan myself, I was incredibly excited when Rovio and Lucasfilm teamed up. From the moment we started creating the Angry Birds *Star Wars* game, it was crucial for us to bring together the best sides of both worlds to delight fans of these hugely popular franchises. But what's really great is that Angry Birds *Star Wars* has rapidly become a universe all of its own, and over the course of the two games, our fans will experience key moments from the whole *Star Wars* saga.

The games have also introduced *Star Wars* to a new, younger generation that perhaps wasn't so familiar with the classic movies. Players of all ages are usually fascinated by the story as well as the unique powers and technology we see in the *Star Wars* universe. And who hasn't dreamt of one day wielding a lightsaber, or perhaps going on their own inter-galactic adventure?

To delight curious fans around the world, National Geographic takes a close look at the key events and characters from the Angry Birds *Star Wars* games. And there's also a special look at the technology on show to see what could go from being science fiction to science fact in the near future. So grab your book and travel to a galaxy far, far away with your feathered friends!

Peter Vesterbacka
Mighty Eagle & CMO
Rovio Entertainment Ltd.

Messier 81 is
a spiral galaxy
far, far away—
12 million
light-years,
to be exact.

A STELLAR COMBINATION

Some of the best things in life are the result of an unexpected combination. Chocolate and peanut butter (a classic). Hall and Oates (ask your parents). And now there's Angry Birds *Star Wars*, the perfect blending of the world's most popular game with the world's most popular space opera.

I've been a *Star Wars* fan my whole life—my red tricycle sported Princess Leia stickers, and Han Solo's fate was hotly debated during the years between *The Empire Strikes Back* and *Return of the Jedi*. To this day, whenever I'm not feeling well, my husband always fixes me the same remedy: Cherry Coke in a Darth Vader glass. Maybe it's nostalgia or maybe it's the Force—but whatever it is, that Darth Vader glass always does the trick.

When Angry Birds first came out, I tried to resist the charms of Red and the gang, but I soon turned to the Bird Side along with the rest of the world. It was impossible to resist a colorful game with a simple premise, a good sense of humor, and a socially acceptable way to smash things. From Seasons to Space, I was hooked.

Then I heard that *Star Wars* and Angry Birds were getting together. I couldn't wait for this unexpected yet intriguing combination. From the thrilling first notes of the blatty version of the *Star Wars* theme music, the gameplay from level to level was wildly imaginative and totally addictive. It was impressive. Most impressive.

Now National Geographic is taking Angry Birds *Star Wars* and mixing it up with what it does best: science. We've taken the distant worlds, the cool vehicles, and the cutting-edge gear and revealed the true science behind the science fiction. Are there planets like Tatooine, and how can we find them? Could a vehicle be powered by light, like the Pigs' TIE fighters? How close are scientists to creating droids like C-3PYOLK and R2-EGG2? Our universe is just as fascinating and strange as the fictional Angry Birds *Star Wars* world.

So let's strap in, fire up the engines, and take off for a galaxy far, far away. . . .

A long tim
galaxy far,

e ago in a
far away....

NATIONAL GEOGRAPHIC

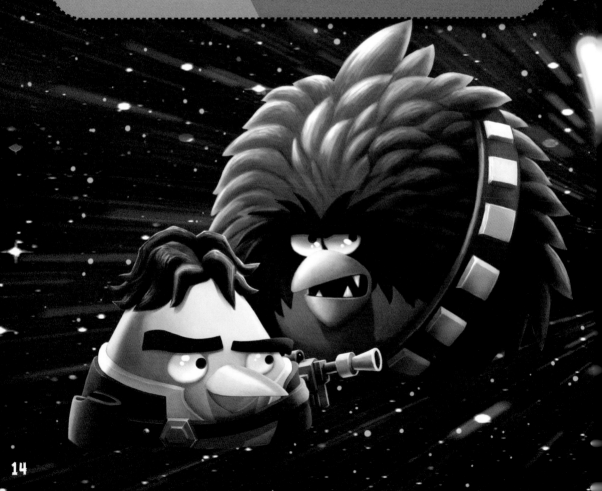

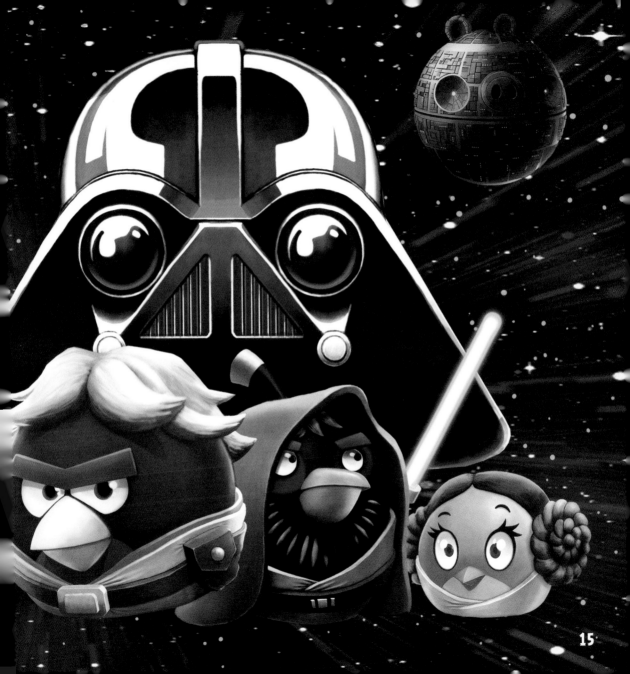

It is a period of anger. A group of angry
Bird Rebels is fighting against the evil
Pig Empire. Imperial leader LARD VADER
believes the birds possess THE EGG, a
relic that contains the ultimate power
in the galaxy. Vader pursues the ship
of Rebel leader PRINCESS STELLA to the
planet of Tatooine. Before the ship's
capture, two droids, R2-EGG2 and
C-3PYOLK, escape to the planet, where
they meet RED SKYWALKER, a young
farmbird with dreams of flying through
space and fighting the evil Pigs. . . .

THE HERO

Raised on the remote planet of Tatooine, Red Skywalker always has his head in the clouds. His dreams keep him entertained on an otherwise utterly boring planet that never has anything exciting going on. Young, impetuous, and just a little bit clumsy, Red has a natural talent for flying. This dreamer longs to soar among the stars, but he has had to keep his feet firmly planted on the planet's rocky ground.

JEDI 101

But after two droids, C-3PYOLK and R2-EGG2, enter Red's life, things begin to change. They lead him to Obi-Wan Kaboomi, an old hermit bird who reveals himself to be a Jedi Bird Master. Obi-Wan agrees to teach Red the ways of the Force so the young bird can join the fight against the evil Pig Empire. Red is excited to be learning the ways of the Jedi, but he has a lot to learn if he's going to save the galaxy.

RED SKYWALKER

ALLEGIANCE: BIRD REBELLION

SPECIES: BIRD

SPECIAL SKILLS: GOOD PILOT; STRONG WITH THE FORCE

PERSONALITY: ENTHUSIASTIC, BUT A BIT CLUMSY

(FORCE FACT)

ASTRONOMERS ESTIMATE THAT EACH GALAXY CONTAINS 10 MILLION TO 3 TRILLION STARS.

TATOOINE
PLANET OF THE TWIN SUNS

SCIENCE FICTION

Red Skywalker grew up on the desert world of Tatooine, a remote planet far, far away from the center of the galaxy. Hot, dusty, and dry, Tatooine orbits two suns whose light scorches the planet and has dried up much of the water. Believed to be one of the galaxy's most ancient worlds, Tatooine was once, long ago, covered by oceans. Although the present surface is covered by large swaths of desert sands, its rock formations and canyons still bear fossilized signs of a primeval watery past.

FORCE FACT

IN 2012, AMATEUR ASTRONOMERS DISCOVERED PH1, AN EXOPLANET THAT HAS FOUR SUNS!

Tatooine's twin suns bake Red Skywalker's home and the desert sands around it.

SCIENCE FACTS

In our own solar system, Mars is the planet that has the most in common with the fictional Tatooine. Like Tatooine, Mars's surface is dry and rocky, with large barren areas of sand in addition to its distinctive and strange-looking rock formations and canyons. But this geology reveals that Mars, too, once had liquid water—the rocks and soil have patterns that show how water once freely flowed over the Martian surface in streams and seas. Scientists are not in agreement as to what happened to Mars's water, but the Mars rover Curiosity is collecting data to give more insight into Mars's mysterious past.

TATOOINE

CLIMATE:
HOT, DRY DESERT

NUMBER OF SUNS: 2

NUMBER OF MOONS: 3

POINTS OF INTEREST:
MOS EISLEY SPACEPORT,
BEGGAR'S CANYON

PLANET HUNTER

Mars, however, only orbits one sun. To find a planet that orbits two suns, like Tatooine, scientists needed to look deeper into space. To help them in their search for exoplanets (planets orbiting other stars), NASA scientists employed the Kepler space telescope. Launched in 2009, the Kepler telescope searches portions of the Milky Way galaxy for other planets and star systems. Unfortunately, in 2013, a stabilizing wheel on the telescope failed, and the telescope's future is uncertain. Its legacy, however, is undeniable: So far, Kepler has discovered more than 2,700 planet candidates and 132 confirmed exoplanets.

A BOUNTY OF BINARY SYSTEMS

In 2011, NASA announced that Kepler had found the first planet that orbits two suns. A frigid gas giant about the size of Saturn, Kepler-16b was spotted when it crossed in front of, or transited, its two suns, causing them both to dim. A year later, an even bigger binary discovery was made—not one, but *two* planets orbiting two suns. The inner planet, Kepler-47b, is too hot for liquid water, but the other, Kepler-47c, orbits its suns at a distance where water could exist. Astronomers are skeptical that life could be present, though, because 47c appears to be slightly larger than Neptune, making it a likely gas giant. Astronomers believe that more binary systems— perhaps as many as two million—are out there, waiting to be discovered.

AN AMAZING VIEW

The Kepler telescope scans the skies in a star-rich area of the constellations Cygnus and Lyra.

An artist's depiction of Kepler-16b, the first exoplanet known to orbit two suns.

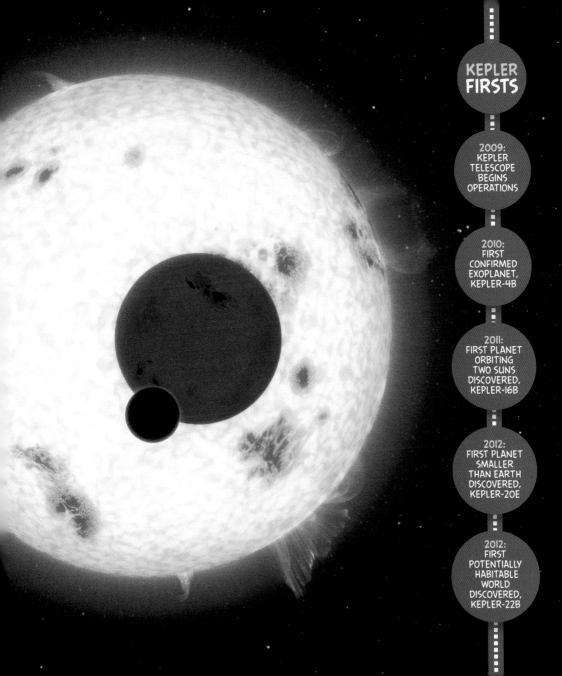

KEPLER FIRSTS

2009:
KEPLER TELESCOPE BEGINS OPERATIONS

2010:
FIRST CONFIRMED EXOPLANET, KEPLER-4B

2011:
FIRST PLANET ORBITING TWO SUNS DISCOVERED, KEPLER-16B

2012:
FIRST PLANET SMALLER THAN EARTH DISCOVERED, KEPLER-20E

2012:
FIRST POTENTIALLY HABITABLE WORLD DISCOVERED, KEPLER-22B

C-3PYOLK & R2-EGG2

< C-3PYOLK

ALLEGIANCE: BIRD REBELLION

FUNCTION: PROTOCOL DROID

SPECIAL SKILLS: INTERPRETER, FLUENT IN OVER SIX MILLION FORMS OF COMMUNICATION

PERSONALITY: PEACEFUL, BUT A BIT HIGH STRUNG; OFTEN FALLS TO PIECES

FORCE FACT

THE FIRST HUMANOID ROBOT IN SPACE WAS NAMED ROBONAUT 2, R2 FOR SHORT.

THE *ODD* COUPLE

Rebel leader Princess Stella sent C-3PYOLK and R2-EGG2 to Tatooine to keep them from falling into the hands of the Empire. The two droids land on the planet and join up with Red Skywalker and Obi-Wan Kaboomi in their crusade against the Pigs.

A PERFECT TEAM

Although they are united in their mission to defeat the evil Pigs, the droids' programming could not be more different. Golden C-3PYOLK is a protocol droid and can be overly fussy, but his peaceful programming compels him always to seek out a diplomatic solution. Short and feisty, little R2-EGG2 prefers to give his enemies a good shock. This astro-mech droid excels at fixing computers and machines, but he also hides an important secret—one he will guard with his life.

R2-EGG2 ∨

ALLEGIANCE: BIRD REBELLION

FUNCTION: ASTROMECH DROID

SPECIAL SKILLS: STORING AND RETRIEVING INFORMATION; COMPUTER REPAIR

PERSONALITY: GOOD AT KEEPING SECRETS; LOVES TO SHOCK ENEMIES

DROIDS
ROBOTS THAT LEARN

Droids like C-3PYOLK and R2-EGG2 are pretty smart, with the ability to learn and to communicate. They help the Bird Rebels by performing complex tasks, like translating alien languages or navigating through hyperspace. They also possess human characteristics and have distinct personalities. Because of their abilities, these droids are able to be of great service to the Bird Rebels.

THE DROIDS WE'RE LOOKING FOR

Scientists are working on creating smarter robots that can help real people in their everyday lives. At Carnegie Mellon University's Robotics Institute, the Home Exploring Robot Butler, or HERB, is leading the charge toward independent robotic discovery. Before HERB could work with an object, the CMU engineers used to have to create a digital model of it and load it into HERB's memory. Now, new programming has enabled HERB to use its own "senses" to explore and learn on its own. HERB can negotiate human spaces, discover and remember new objects, and manipulate them. The CMU team expects that HERB and robots like it will someday be capable of assisting people—especially older adults and people with disabilities—with household tasks.

ROBOT MILESTONES

1920: PLAYWRIGHT KAREL CAPEK COINS THE WORD "ROBOT."

1961: THE UNIMATE, THE FIRST PROGRAMMABLE INDUSTRIAL ROBOT, GOES INTO ACTION AT A GENERAL MOTORS PLANT.

1997: THE IBM COMPUTER DEEP BLUE DEFEATS WORLD CHESS CHAMPION GARRY KASPAROV.

2002: ROOMBA, THE FIRST AUTONOMOUS ROBOT VACUUM CLEANER, IS INTRODUCED.

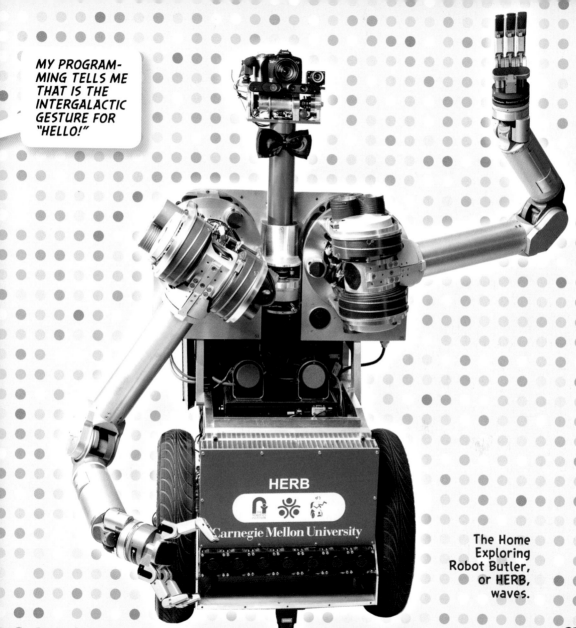

MY PROGRAM-
MING TELLS ME
THAT IS THE
INTERGALACTIC
GESTURE FOR
"HELLO!"

HERB

Carnegie Mellon University

The Home
Exploring
Robot Butler,
or HERB,
waves.

OBI-WAN KABOOMI
THE PROFESSOR

A mysterious old hermit, Obi-Wan Kaboomi has dwelled alone out on Tatooine's desolate wastelands for many years. From a distance, this old bird has watched over Red Skywalker all his life, quietly waiting for the right opportunity to teach the young bird the ways of the Force.

AN EXPLOSIVE LESSON

After rescuing Red from an attack by the Sand Pigs, Obi-Wan reveals his true identity. The old bird is really a powerful Jedi Bird Master, with a great affection for explosions. He will teach Red in the ways of the Force as the two of them join forces to defeat the Pig Empire and protect the galaxy from evil.

OBI-WAN KABOOMI

ALLEGIANCE: JEDI BIRD
COUNCIL AND BIRD REBELLION

SPECIES: BIRD

SPECIAL SKILLS:
JEDI MASTER OF THE FORCE

PERSONALITY:
A PROUD WARRIOR
AND MENTOR TO RED;
HAS A SHORT FUSE

FORCE FACT
THE LARGER A STAR'S MASS,
THE SHORTER ITS LIFE SPAN WILL BE.

GALACTIC GEAR

LIGHTSABER
AN ELEGANT WEAPON

SCIENCE FICTION

The traditional weapon of the Jedi Knights, lightsabers have blades made of pure energy that can cut almost anything, except another lightsaber. Within the handle is a power cell and a special colored crystal that create light. Focused by a disk at the top of the handle, the beam transforms into a humming blade of energy. Obi-Wan Kaboomi gave Red Skywalker a blue lightsaber after he began his training, while evil Lard Vader is known for his menacing red lightsaber.

SCIENCE FACTS

Lightsabers are still safely in the realm of science fiction, but Energetic Materials & Products, a Texas company, may have invented the closest thing yet—an ultrahot torch that can cut through steel bars in seconds. About the size of a flashlight, the Metal Vapor Torch (MVT) uses the chemical reaction of copper oxide, magnesium, and aluminum particles to generate a blade of flame that burns hotter than 5000°F (2700°C). The MVT's flame lasts only a few seconds, so users must rely on disposable fuel cartridges. The tool was created for police and other first responders, because they often need to quickly cut through metal locks or debris to help victims.

HOT! **HOT!** HOT!

During a demonstration of its cutting power, the Metal Vapor Torch slices through metal bars, locks, and chains.

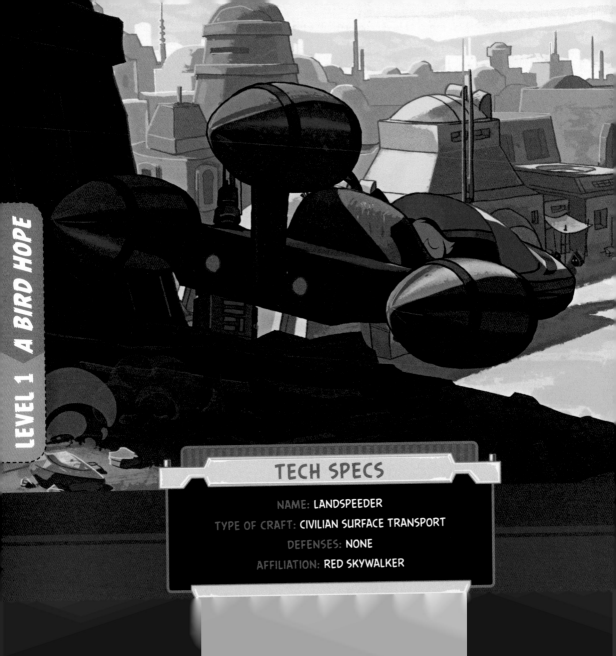

TECH SPECS

NAME: LANDSPEEDER

TYPE OF CRAFT: CIVILIAN SURFACE TRANSPORT

DEFENSES: NONE

AFFILIATION: RED SKYWALKER

LANDSPEEDER
FLOATING ON AIR

When Red Skywalker decides to join Obi-Wan Kaboomi, the two of them hop into Red's land-speeder to travel to a nearby spaceport. Repulsorlift propulsion engines suspend the craft off the ground, while two turbines power it forward so that the landspeeder effortlessly skims over just about any surface. It's the perfect mode of transportation for zipping over the hot sands of Tatooine.

HOVERCRAFT

The technology that lifts up Red's landspeeder closely resembles the real-world science behind hovercraft. A fan on the craft generates a cushion of air for the vehicle to float on as it is driven. Invented in 1956, hovercraft now come in many shapes and sizes. A technology firm in California is developing a personal-size hover vehicle that is as easy to ride as a bicycle. Its new "hoverbike" features a simple mechanical steering system that responds to a pilot's movements and balance, making learning to fly very easy and intuitive. The engineers are hopeful that this smaller, maneuverable craft can help emergency personnel quickly travel to places that could be

A HOVERBIKE RIDE

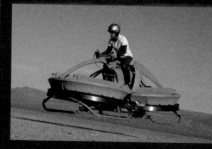

The Aerofex hoverbike can rise up to 15 feet (4.5 m) in the air and reach speeds of about 30 miles an hour (48 kph).

Princess Stella helps R2-EGG2 escape from the Pig Empire.

34

CHUCK "HAM" SOLO & TEREBACCA

THE SCOUNDREL & THE STRONGMAN

Smuggler Chuck "Ham" Solo and his copilot Terebacca fly the fast freighter *Mighty Falcon*. Cocky and self-confident, Solo is not only an excellent pilot but also a crack shot with his blaster. His partner Terebacca is the strong, silent type; what little he says is under-stood only by Solo. The two have no love for the Pig Empire and rely on their superfast ship to avoid any Imperial entanglements.

< TEREBACCA

ALLEGIANCE:
BIRD REBELLION

SPECIES: BIRDIEE

SPECIAL SKILLS:
COPILOT; MECHANIC

PERSONALITY: STRONG,
SILENT TYPE

< CHUCK "HAM" SOLO

ALLEGIANCE: BIRD REBELLION

SPECIES: BIRD

SPECIAL SKILLS: SMUGGLER;
HANDY WITH A BLASTER

PERSONALITY: A SELF-
CONFIDENT SCOUNDREL
WITH NO LOVE FOR
THE EMPIRE

JOINING THE REBELLION

Solo often owes money to crooks, so he's always on the lookout for new ways to make some cash. Solo hires himself out to Red and Obi-Wan after they meet in a cantina. With the Pigs in hot pursuit, Solo and Terebacca join the Rebel crew when they all blast off Tatooine together aboard the *Mighty Falcon*.

GALACTIC GEAR

GEAR: BLASTER PISTOL

TYPE: RANGED WEAPON

DAMAGE TYPE: INTENSE LIGHT ENERGY

SPECIAL ABILITIES: BURNS THROUGH ALLOYS, POPS PIGS

HAM SOLO'S BLASTER
LASER POWERED

SCIENCE FICTION

When Greedork the bounty hunter confronts Ham Solo in the cantina, the cocky bird is not worried. Solo has his trusty blaster pistol by his side and soon makes quick work of his pesky Pig problem. Blasters are the most common weapon in the galaxy, coming in all shapes and sizes—from small pistols to rifles to cannon. No matter the size, each blaster type fires concentrated beams of high-energy particles. Reliable and accurate, blasters are Solo's weapon of choice.

SCIENCE FACTS

Laser pistols seem to be a favorite element of any science fiction story. Handheld blasters aren't a reality yet, but large laser weapons are quite real. In 2013, the U.S. Navy announced that it will equip the U.S.S. *Ponce* with the Laser Weapon System (LaWS), a big laser cannon that can take down aircraft. Development of personal blasters is a lot further away, for several reasons. First, to generate a blast sufficient to cause damage, they would require a large power source. The LaWS can draw on the giant power supply from the Navy ship, but no portable energy source exists that could be used on something as small as a handheld blaster. Second, lasers get very hot when they fire, so the blaster would need a cooling system. With today's technology, a blaster pistol would be too bulky to carry around, so for now the larger cannon models will have to do.

LASER BEAMS ON BOATS

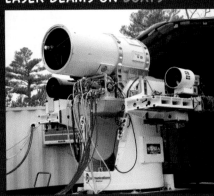

This giant prototype laser shot down an unmanned aerial vehicle during development of the U.S. Navy's Laser Weapon System (LaWS).

MIGHTY FALCON

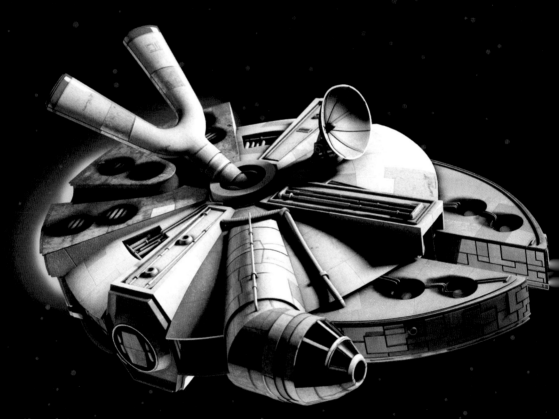

Ham Solo uses the *Falcon* to smuggle junk food.

40

THE FASTEST HUNK OF JUNK IN THE GALAXY

Piloted by Ham Solo and Terebacca, the *Mighty Falcon* might not look like much, but she's got it where it counts. On the outside, the ship looks like a battered old freighter, but that clever disguise masks Solo's special modifications that have turned the *Falcon* into one of the fastest, best equipped transport vessels in the galaxy. When Red Skywalker and Obi-Wan Kaboomi needed transport off of Tatooine, they sought out Solo and his ship to help them escape the Pigs.

SPACE FREIGHT

The *Mighty Falcon* takes the Bird Rebels from one planet to another. Interstellar space travel is still firmly in the realm of science fiction, but vehicles taking people and supplies into space has been a reality for humans since the mid-20th century. In 1961, a rocket from the Soviet Union launched the capsule Vostok I into orbit and along with it cosmonaut Yuri Gagarin, the first person in space. Aboard the Vostok, he made one orbit around Earth, exited the capsule, and parachuted back to the ground. The Vostok I capsule crash-landed, never to fly again, but its remains are on display in the RKK Energiya museum in Russia.

TECH SPECS

NAME: *MIGHTY FALCON*

TYPE OF CRAFT: FREIGHTER

DEFENSES: RETRACTABLE SLINGSHOT, LASER CANNON

AFFILIATION: HAM SOLO

SPACE SHUTTLE

As space travel technology improved, spacecraft could accommodate more and more passengers and cargo. For the first 20 years of spaceflight, rockets were designed for one-time use. But then in the 1980s, NASA introduced the Space Shuttle program, featuring a fleet of ships that could blast off like a rocket and land like an airplane, which allowed them to be flown over and over again. From 1981 to 2011, the fleet flew 135 missions, many of which transported international crews to the Mir space station and delivered the materials that would build the International Space Station (ISS).

ENTER THE DRAGON

The shuttle program was retired in 2011, temporarily bringing an end to reusable spacecraft. Private companies saw this opportunity, though, and began to get involved in commercial space travel—transporting cargo as well as people. SpaceX, a space transportation company in California, contracted with NASA to take cargo to and from the ISS. SpaceX designed its own reusable capsule, the Dragon, and a rocket system to launch it. Beginning in 2012, the Dragon made several successful trips to the ISS. Now SpaceX is one of the companies competing to create a manned version of the Dragon for NASA that would carry crews of up to seven astronauts back and forth between Earth and the ISS.

SPACE SHUTTLE STATS

During their careers, the five space shuttles flew 135 times, carried 355 people, and logged more than 500 million miles.

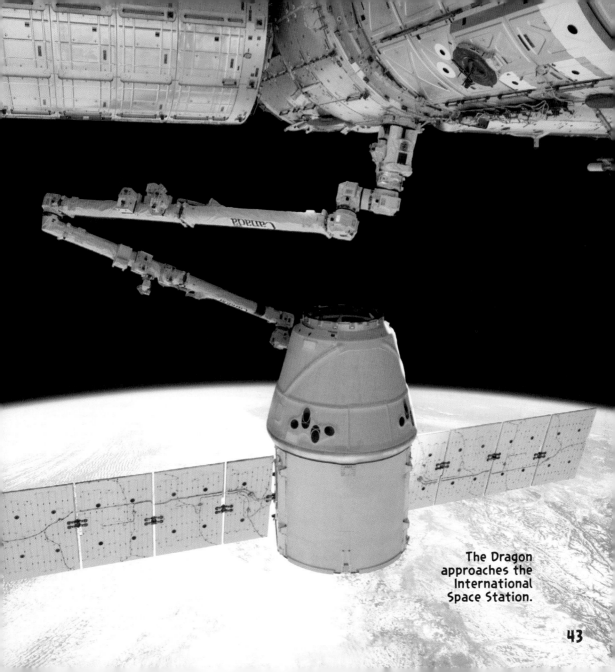

The Dragon
approaches the
International
Space Station.

LARD VADER
THE VILLAIN

Twisted and evil, Lard Vader inspires fear wherever he goes. One of the most feared leaders of the Pig Empire, this bad guy used to be a Jedi Bird knight before he turned to evil and donned his jet-black suit of armor. Vader's true identity remains a secret, his face hidden behind a sinister mask.

EGG CHASER

Vader is certain the Bird Rebels have the key to the universe's ultimate power: The Egg. He relentlessly pursues them to take it for himself. He'll never stop chasing them, for Vader's insatiable appetite for power is matched only by his bottomless appetite for junk food. He serves the Empire, but has secret plans to seize power for himself and rule the galaxy.

LARD VADER

ALLEGIANCE: PIG EMPIRE

SPECIES: BIRD CYBORG

SPECIAL SKILLS: MASTERY OF THE PORK SIDE OF THE FORCE

PERSONALITY: ENORMOUS APPETITE FOR POWER AND JUNK FOOD

FORCE FACT
M&M CHOCOLATE CANDIES WERE A FAVORITE TREAT ON ALL THE SPACE SHUTTLE MISSIONS.

GALACTIC GEAR

GEAR: LARD VADER'S ARMOR

COVERAGE: LARD VADER'S BODY

PROTECTS AGAINST: BLASTER BOLTS, HEAT, COLD, ELECTRICAL ENERGY, EXPLOSIONS, PIERCING, SLASHING, POISON

SPECIAL ABILITIES: LIFE-SUPPORT SYSTEM, TEMPERATURE REGULATION

LARD VADER'S ARMOR
THE ULTIMATE SPACE SUIT

SCIENCE FICTION

Lard Vader's armor protects him from almost anything, but his armor has a secondary purpose: life support. Before Lard Vader turned to the Pork Side, his body was horribly damaged during a battle. To keep him alive, his suit must regulate his body functions like breathing and temperature. It enables him to survive just about anywhere—even in airles[s], rigid outer space.

SCIENCE FACTS

Since Americans first began exploring space, space suits have been designed for each mis[s]ion's needs. When traveling to the Moon, the suit needed a separate life-support syste[m] so astronauts could roam freely on the surface. When focus shifted to spacewalks and building the International Space Station, suits had to protect from the extreme cold of space and contain a mobile life-support system and oxygen supply. NASA is now working on a new prototype—the Z-1, a versatile suit that can explore alien surfaces, float outside a space station, and withstand deep-space radiation. A suit like this could be worn outside the space station, on the Moon, or possibly on Mars.

SUITING UP!

APOLLO:
1969

EMU:
2002

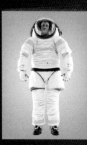

Z-1 PROTOTYPE:
2012

THE PIG STAR
SUPERSIZED SPACE STATION

Floating out in the darkness of space is the Pig Empire's ultimate weapon: the Pig Star. The size of a small moon, this massive space station is the Pigs' base of operations. Here, they plot their galaxy-wide search for The Egg. Defended by tractor beams, ion cannon, and laser turrets, the giant Pig Star provides a perfectly protected Pig habitat in space where they can safely stash all the junk food they want while planning their attacks on the Bird Rebels.

SPACE STATIONS FOR SCIENCE

Real space stations are human habitats in orbit around Earth that allow astronauts to spend a lot of time off world. Space stations play an important role in scientific research—from determining the effects of microgravity to observing the planet from above. The first space station, Salyut I, was launched by the Soviet Union in 1971. The United States followed in 1973 with Skylab, but quickly abandoned its space station program the following year. The first humans to visit these stations didn't stay for long—only a few weeks at a time—because nobody knew the effects of long-duration spaceflight on people.

TECH SPECS

NAME: PIG STAR

TYPE OF CRAFT:
SPACE STATION

PURPOSE: GIANT STATION
FOR ATTACKING BIRD REBELS
AND STORING GEAR AND
JUNK FOOD

AFFILIATION: PIG EMPIRE

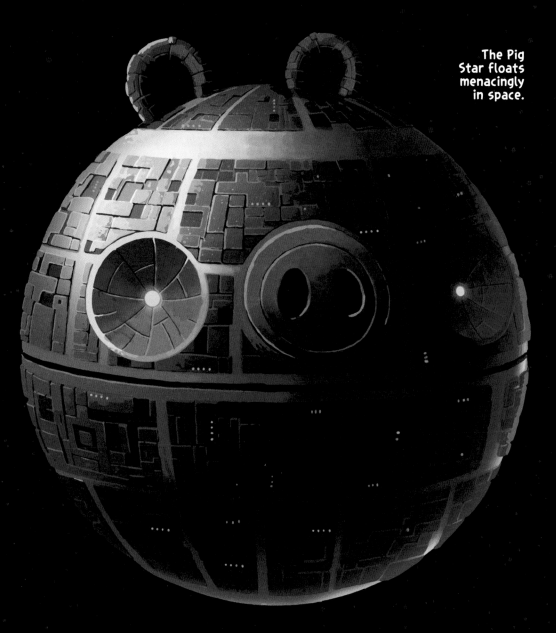

The Pig
Star floats
menacingly
in space.

49

THE MIGHTY MIR

As scientists learned that spending time in space didn't hurt humans, new space stations were built to accommodate extended stays. Launched in 1986, the Mir was a Russian modular space station that could house up to six people at a time. The station allowed cosmonauts to conduct research on space technology, astrophysics, biology, and the long-term effects of microgravity on people. The station orbited the Earth for more than 15 years before being decommissioned when Russia turned its attention to funding the International Space Station (ISS). In 2001, the Mir deorbited and fell into the Pacific Ocean.

AN INTERNATIONAL EFFORT

Fifteen countries collaborated to put the ISS, the largest man-made structure in space, into orbit. The first section of the flying space laboratory was launched in 1998, and today the station has grown to be about as big as an American football field with as much living space as a five-bedroom house. But unlike the fictional Pig Star, which can house battalions of Pigtroopers, the International Space Station supports a more modest number— a permanent crew of six with the potential to host four more, tops. The ISS is a giant space laboratory with ongoing experiments in many areas, including space agriculture, Earth science, technology, and microgravity.

ROCK STAR!

Canadian astronaut Chris Hadfield gained fame in 2013 with his rendition of David Bowie's "Space Oddity," sung from the International Space Station.

An American and a Swedish astronaut work together to upgrade the International Space Station.

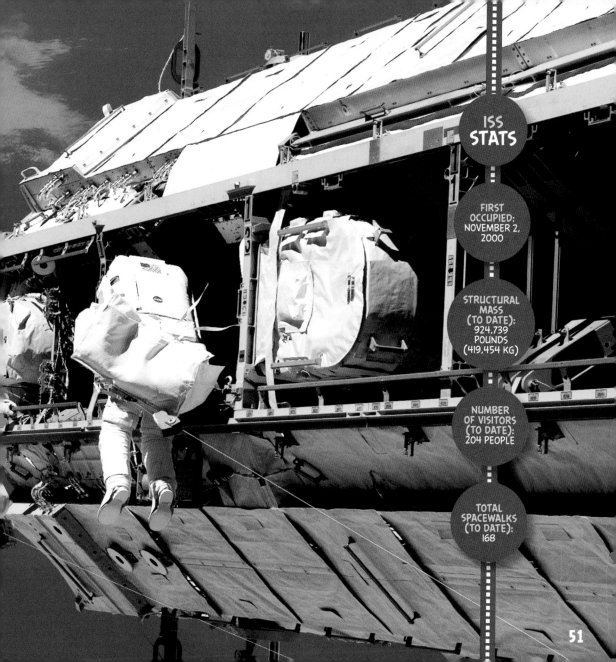

ISS STATS

FIRST OCCUPIED: NOVEMBER 2, 2000

STRUCTURAL MASS (TO DATE): 924,739 POUNDS (419,454 KG)

NUMBER OF VISITORS (TO DATE): 204 PEOPLE

TOTAL SPACEWALKS (TO DATE): 168

51

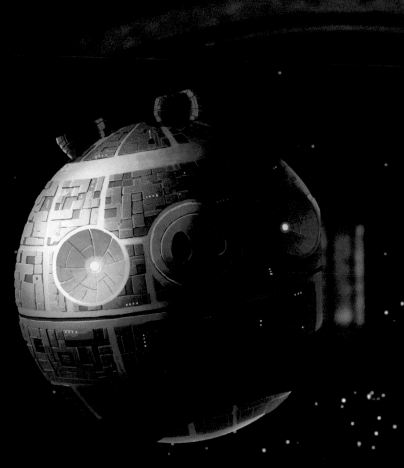

A terrifying sight:
The Pig Star rises up
in front of the *Mighty
Falcon's* cockpit.

A large impact crater on Saturn's moon Mimas gives it a striking resemblance to the Pig Star.

Three birds working together, the Blue Squadron are the Bird Rebels' most elite group of combat pilots. Under the command of Red Skywalker and the Bird Rebel leaders, these courageous daredevils soar through space at the controls of their X-wing birdfighters to protect the galaxy from the Pig Empire.

UNITED AS ONE

Within the halls of their secret Rebel base, these three incredible heroes make plans to attack the Pig Star, the Empire's deadly space station. To destroy it, they know they must combine their forces to overcome the station's defenses, including laser towers, TIE fighters, and the evil Lard Vader himself. The Rebellion is counting on it.

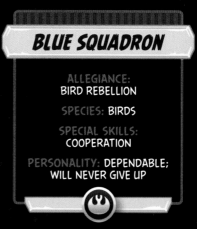

BLUE SQUADRON

ALLEGIANCE:
BIRD REBELLION

SPECIES: BIRDS

SPECIAL SKILLS:
COOPERATION

PERSONALITY: DEPENDABLE;
WILL NEVER GIVE UP

(FORCE FACT)
ROCKETS MUST TRAVEL AT LEAST 25,000 MILES AN HOUR (40,200 KPH) TO ESCAPE EARTH'S GRAVITY.

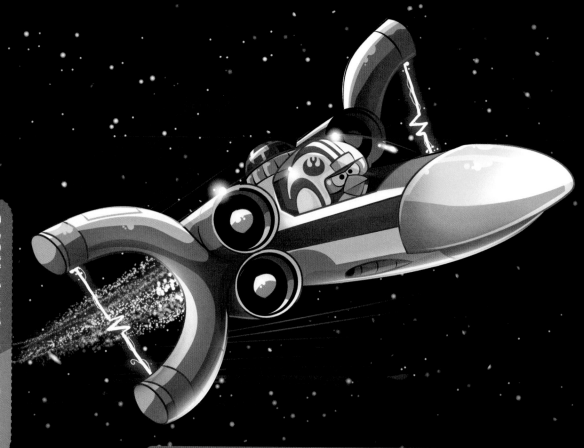

TECH SPECS

NAME: X-WING

TYPE OF CRAFT: BIRDFIGHTER

WEAPONS: LASER CANNON, PROTON TORPEDOES

AFFILIATION: RED SKYWALKER, BLUE SQUADRON

X-WING BIRDFIGHTER
SUBATOMIC POWER

When the Bird Rebels take on the Pig Star, their best pilots are flying X-wing birdfighters. Fast and agile, X-wings are powered by sublight ion engines, making these ships the fastest in the Rebel fleet. Like the *Mighty Falcon,* X-wings can also jump to light speed, thanks to the astromech droids that sit in a socket behind the cockpit. The droids' powerful computers manage navigation, repairs, and the coordinates for the jump to hyperspace.

IONIC PROPULSION

Scientists haven't mastered light-speed travel yet, but they have been using ionic-powered engines in space for quite a while. NASA's Dawn spacecraft, launched in 2007 to explore the asteroid belt, relies on these kinds of engines for power. Ionic propulsion systems are very efficient and require less fuel than rockets, which means spacecraft can travel faster, farther, and cheaper. For its next big mission to the asteroid belt, NASA is developing a new ionic-propulsion thruster that uses xenon ions. If successful, this engine could become part of NASA's Asteroid Retrieval Initiative, a plan to capture a small asteroid, redirect it into a stable orbit around Earth, and send astronauts to explore its surface.

XENON **BURNS BLUE!**

This ionic engine uses xenon gas, which glows blue during a 2013 test at NASA's Jet Propulsion Laboratory in Pasadena, California.

PIGTROOPERS
THE FOOT SOLDIERS

Servants of the Empire, the Pigtroopers have been tasked with hunting down and wiping out Rebel forces wherever they find them. Their bright white armor has been adapted for several different climates—from the hot sands of Tatooine to the cold snows of Hoth—so they can search for the Bird Rebels just about anywhere in the universe.

A FEW SANDWICHES SHORT OF A PICNIC

Despite being fearsome soldiers, the Pigtroopers aren't known for their intellect. When selecting Pig-trooper candidates, Imperial commanders purposely look for the Pigs least likely to think for themselves, because Pigtroopers must take orders, never question their leaders, and be mindlessly loyal to their emperor.

PIGTROOPERS

ALLEGIANCE: PIG EMPIRE

SPECIES: PIGS

SPECIAL SKILLS:
TAKING ORDERS;
NOT QUESTIONING

PERSONALITY: JUNK FOOD
LOVERS; COMPLETELY LOYAL
TO THE EMPIRE

FORCE FACT
TODAY'S SPACE SUITS COST $12 MILLION EACH TO MAKE.

IMPERIAL ARMOR
PROTECTING THE TROOPS

Lightweight and snowy white, the Pigtroopers' spotless armor protects them from a broad range of attacks—from hot laser blasts to smashing physical impacts. Made of plastoid plates, the armor allows the Pigs to move around quickly and easily—unless they're too gorged on junk food! The specialized helmets clean the air they breathe, provide communications channels, and protect trooper noggins from head injuries. Pigtroopers even have specialized suits of armor for extreme weather—like the burning hot desert of Tatooine or the icy tundra of Hoth.

LIGHTER, FASTER, BETTER

Real-life soldiers also wear battle armor to protect them from harm, but instead of defending against lasers and lightsabers, real soldiers need protection from things like bullets and shrapnel. Still, battle armor must balance the needs for mobility, comfort, and protection. Steel plates may give soldiers strong protection, but they are heavy and make it difficult to maneuver. Engineers have been working on developing lighter, thinner substances. Today, protective armor is made from synthetic materials like Kevlar and Dyneema, which can weigh up to 25 percent less than steel. These lightweight, flexible, strong substances are found in combat helmets and bulletproof vests, including the U.S. Army's Improved Outer Tactical Vest. With each new innovation, battle armor gets lighter and gives better protection to soldiers in uniform.

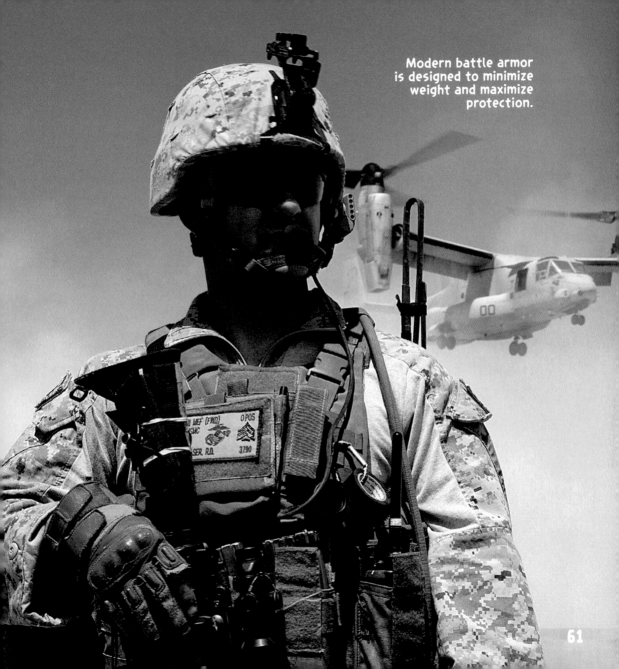

Modern battle armor is designed to minimize weight and maximize protection.

TECH SPECS

NAME: TIE FIGHTER

TYPE OF CRAFT: PIGFIGHTER

WEAPONS: LASER CANNON

AFFILIATION: PIGTROOPERS

TIE FIGHTER
POWERED BY STARLIGHT

When the Bird Rebels begin their attack on the Pig Star, they've got to face a squadron of the Pig Empire's dangerous TIE (Twin Ion Engine) fighters. Extremely light and superfast, these ships harness the power of starlight to drive their powerful engines. Two massive solar array panels adorn the wings on either side of the ship to collect the light that fuels the fight.

A SOLAR IMPULSE

The panels seen on the TIE fighters' wings have real-world equivalents. Called photovoltaic cells, or solar panels, they collect sunlight and convert it into electricity. Most commonly seen on the roofs of houses or on spacecraft like the International Space Station, solar-powered vehicles on Earth are a rarity. But solar power aviation is making some giant strides. In 2010, the *Solar Impulse* became the first solar-powered plane to be able to fly at night. Then in 2013, it successfully flew across the United States without using any fuel. The *Solar Impulse* flies slowly—cruising at about 30 miles an hour (48 kph). Nearly 12,000 solar cells are mounted on its wings and tail, powering the plane's four motors. The Solar Impulse team is looking ahead to 2015, when they hope their solar-powered plane will become the first to fly around the world.

LIGHT AS AIR?

The *Solar Impulse*'s wingspan is as long as an Airbus A340's, but it weighs only as much as an average car.

LEVEL 2 THE PIGS STRIKE BACK

It is a dark time for the Bird Rebellion.

Although the birds scored a major victory when the PIG STAR was destroyed, the Pig Empire continues to chase them across the galaxy, still searching for the mysterious, powerful EGG. The Bird Rebels, led by PRINCESS STELLA and RED SKYWALKER, have set up a secret base on the frozen planet of Hoth. But the evil LARD VADER has detected their presence on the planet and is on the verge of launching a surface attack. . . .

PRINCESS STELLA ORGANA
THE REBEL WITH A CAUSE

Smart, brave, and beautiful, Princess Stella Organa is one of the fearless leaders of the Bird Republic. Decisive and a little bit stubborn, she is used to giving orders and having them obeyed. A crack shot with her tractor beam, Princess Stella will let nothing stop her in her quest to defeat the Pigs and save the galaxy.

A RELUCTANT CRUSH

It was Stella who first sent the droids to find Obi-Wan Kaboomi and kept the Pig Empire from capturing them. During their time on the Rebel base on Hoth, she and Red Skywalker have developed a close friendship, but Princess Stella finds herself liking cocky Ham Solo, too, against her better judgment.

PRINCESS STELLA ORGANA

ALLEGIANCE: BIRD REBELLION

SPECIES: BIRD

SPECIAL SKILLS:
GIVING ORDERS; USING HER
TRACTOR BEAM

PERSONALITY: A NATURAL
LEADER, BUT HAS
A STUBBORN STREAK

FORCE FACT

VENUS IS THE HOTTEST PLANET IN THE SOLAR SYSTEM.

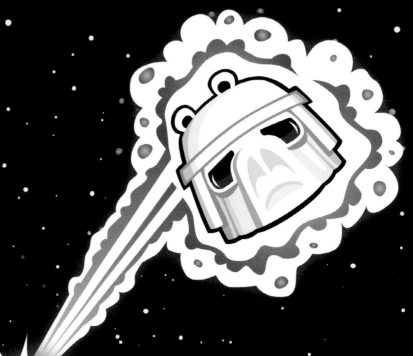

GALACTIC GEAR

GEAR: TRACTOR BEAM

TYPE: RANGED WEAPON

DAMAGE TYPE: NONE

SPECIAL ABILITIES: DESTABILIZES STRUCTURES;
PULLS DOWN PIGS

PRINCESS STELLA'S
TRACTOR BEAM
A POWERFUL PULL

SCIENCE FICTION

When enemies spot Princess Stella, they can't help but be impressed by her. Is it her way of squawking, her plaited bun . . . or her tractor beam they find so irresistible? The princess's tractor beam does not cause any damage on its own. When Princess Stella activates it, the weapon projects a force field that captures objects and pulls them in different directions—often destabilizing them. If Imperial forces are caught in the beam, Pigs can fly.

ZAP IT!

An artist's conception of the microscopic tractor beam in action

SCIENCE FACTS

In 2013, Scottish scientists announced that they had developed a tractor beam. But it won't be pulverizing Pigs or zapping starships anytime soon. This tractor beam can move only microscopic particles. Usually when a beam of light strikes small objects, light photons move them in the same direction as the light beam. But the Scottish scientists have discovered a technique that reverses that tendency so that the particles move *toward* the beam of light. As they continue to explore this phenomenon, the team is hopeful that the mini-tractor beam could have microscopic medical applications.

HOTH GIANT DEEP FREEZE

IMPERIAL

SCIENCE FICTION

After the destruction of the Pig Star, the Bird Rebels were forced to relocate their secret base to a new location. They chose Hoth. Cold, desolate, and bounded by a perilous asteroid field, this snow-covered planet is a perfect spot to hide from the Pig Empire. Hoth is covered by thick layers of ice and snow, with surface temperatures that rarely, if ever, reach 32°F (0°C). Deep beneath the icy layers is a liquid ocean that spurts up in geysers due to the gravity of Hoth's moons. The water freezes as soon as it hits the frigid atmosphere and forms tall ice towers.

WALKERS

SCIENCE FACTS

In our own solar system, there are a few places that resemble Hoth. Neptune and Uranus are the two coldest planets by far. Surface temperatures on Uranus can dip to –357°F (–216°C), while Neptune's plummet to –353°F (–214°C). But these two gas giants cannot support life the way Hoth can. The most similar location is actually here on Earth. Covered by snow and ice, Antarctica is the coldest, driest, windiest spot on the planet. The coldest temperature ever recorded here was –128.6°F (–89.2°C). Like on Hoth, there are a few life-forms able to survive in Antarctica's extreme cold.

COMIN' THROUGH!

[FORCE FACT]
ONE YEAR ON NEPTUNE LASTS ABOUT 165 EARTH YEARS.

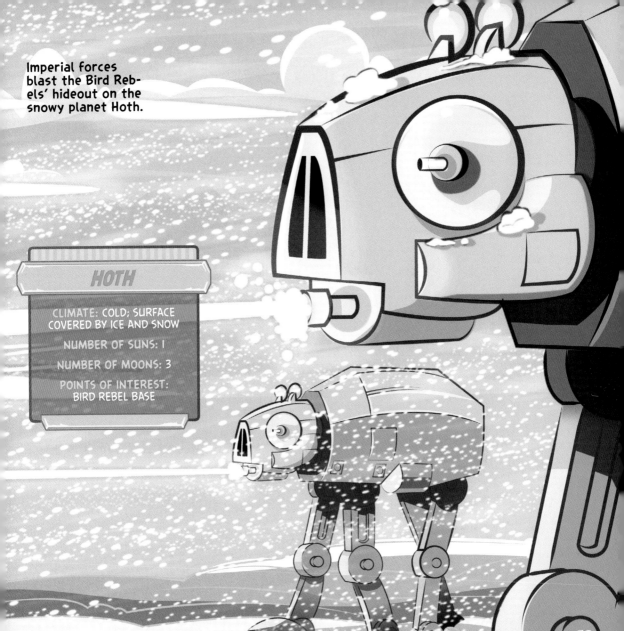

Imperial forces blast the Bird Rebels' hideout on the snowy planet Hoth.

HOTH

CLIMATE: COLD; SURFACE COVERED BY ICE AND SNOW

NUMBER OF SUNS: 1

NUMBER OF MOONS: 3

POINTS OF INTEREST: BIRD REBEL BASE

SUBZERO SATELLITE

There is another real place in our solar system that has a tremendous amount in common with Hoth. Only it isn't a planet—it's a moon. Enceladus is one of Saturn's many satellites (to date 62 have been discovered and 53 named). One of the brightest objects in the solar system, Enceladus reflects almost all of the sunlight that hits it. But because it reflects the light rather than absorbing it, the surface temperature stays very cold, about -330°F (-201°C).

THAT'S SNOW MOON

Enceladus's brightness is caused by the snow that covers the moon's surface. In 2011, the Cassini orbiter took high-resolution images showing that drifts of powdery snow, some as thick as 400 feet (122 m) blanket Enceladus. Cassini has also revealed the presence of icy geysers—a discovery that suggests the presence of a liquid ocean beneath the moon's frozen surface. The geysers spray massive plumes of water vapor and ice particles into the atmosphere that then fall as snow onto the surface. Analysis of the geysers' spray shows that it may contain the chemical ingredients for life, making this moon a prime research target for otherworldly organisms.

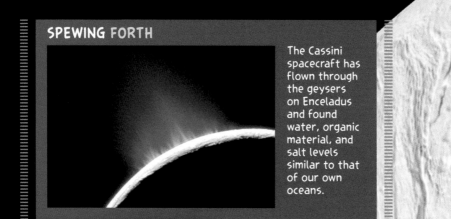

SPEWING FORTH

The Cassini spacecraft has flown through the geysers on Enceladus and found water, organic material, and salt levels similar to that of our own oceans.

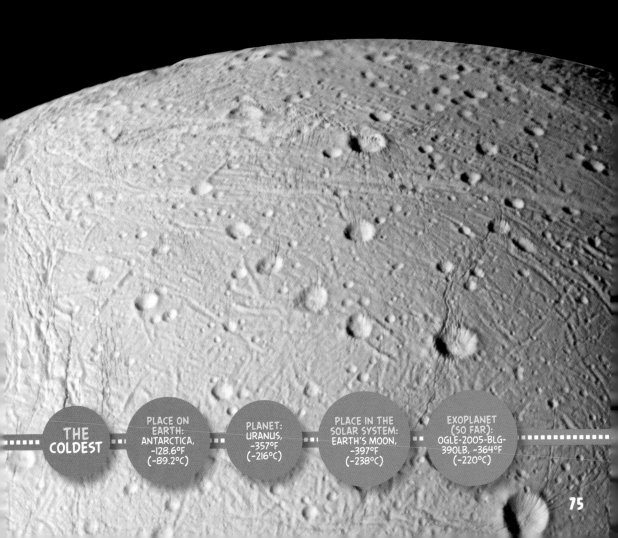

The frosty, cratered
surface of Saturn's
moon Enceladus

THE
COLDEST

PLACE ON
EARTH:
ANTARCTICA,
-128.6°F
(-89.2°C)

PLANET:
URANUS,
-357°F
(-216°C)

PLACE IN THE
SOLAR SYSTEM:
EARTH'S MOON,
-397°F
(-238°C)

EXOPLANET
(SO FAR):
OGLE-2005-BLG-
390LB, -364°F
(-220°C)

The Pig Empire uses probe droids to collect data about other planets.

PROBE DROIDS
RECONNAISSANCE ROBOTS

When Lard Vader needed to find the Bird Rebels' hidden base, he employed an army of probe droids, also called "probots," to spy for the Empire all over the galaxy. Stealthy and sneaky, these jellyfish-shaped droids silently hover over the surfaces of planets, collecting data and sending it back to the Imperial Pigs. Their sensors collect all kinds of information—sights, sounds, smells, vibrations, or anything that could be a clue to the Rebels' location.

SPACE RANGER ROBOTS

The probe droids of fiction share the same mission as the data-gathering robots enlisted by humans: to explore space and send back information. Robots have flown to the farthest reaches of the solar system, taken revealing close-ups of Saturn and its moons, and touched down on the Moon, Venus, Mars, and Jupiter. Probes like Voyagers 1 and 2 have zoomed through the solar system for more than 35 years, all the while sending data back to Earth about the outer limits and beyond. Orbiters are another kind of probe droid that collect data while staying in orbit around a planet; two of the most famous, Galileo and Cassini, orbited Jupiter and Saturn, respectively, and made discoveries that changed the way we think of those two planets and their moons.

CIRCLING SATURN

The Cassini spacecraft—which orbits Saturn to collect data about the planet, its moons, and its rings—has been so successful that its mission has been extended through 2017.

LANDING ON MARS

Perhaps the most well-known probots are the landers and rovers, robots that touch down on a planet's surface to do their work. Mars has hosted most of them, starting with the Viking missions in 1976. The Viking I and 2 landers snapped pictures, took samples of Martian soil and atmosphere, and analyzed them all for composition and signs of life. In 2008, NASA sent the Phoenix lander equipped with a robotic arm to scoop up soil and water-ice samples in a polar region of Mars. Phoenix collected evidence that suggested volcanic activity as well as the presence of liquid water in Mars's past.

FREEWHEELING ROVERS

The next generation of probe droids is the rovers, robots that can go mobile on a planet's surface. The first two landed on Mars in 2004. Named Spirit and Opportunity, they roamed around different spots on the planet to study Mars's climate history through its rocks, dirt, and geologic features. Spirit ceased communications in 2010, but Opportunity is still rolling as of 2013. The next big rover is Curiosity, a mobile space lab that landed on Mars in summer 2012. Curiosity is a mobile science lab, able to move around to collect and analyze rock and soil samples—which means the discoveries will be coming fast and furious. Most recently, the rover found rocks that were part of an ancient streambed, the first find of its kind!

PROBOT FIRSTS

SPUTNIK: FIRST SPACE PROBE, 1957

LUNA 9: FIRST PROBE TO SEND BACK DATA FROM THE MOON, 1966

VENERA 7: FIRST PROBE TO RETURN DATA AFTER LANDING ON ANOTHER PLANET (VENUS), 1970

MARS 3: FIRST ROBOT TO RETURN DATA FROM MARS, 1971

The Mars rover Spirit surveyed the rocky surface of Mars for six years.

THE PHOENIX LANDER DETECTED
SNOW FALLING FROM CLOUDS ON MARS.

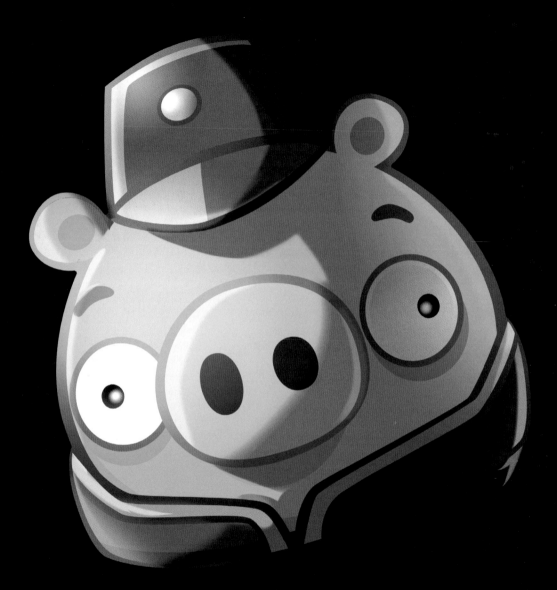

PIG COMMANDER
THE PIG WITH A PLAN

When Lard Vader orders a surface attack on the Bird Rebel base on Hoth, he entrusts the battle plans to a Pig Commander. A trusted officer in the Empire's fighting forces, the commander knows that failure is not an option, so he always uses his best strategies and top tactics to defeat the Bird Rebels.

ARCHITECT OF THE ATTACK

On Hoth, the Pig Commander masterminds the ground assault. He determines where the massive AT-AT walkers will stomp over the planet. He gives the orders to the Pigtroopers, knowing that they will follow his commands without question. And he pinpoints the weaknesses in the Bird Rebels' defenses to ensure the Pig Empire achieves a crushing victory.

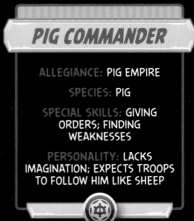

PIG COMMANDER

ALLEGIANCE: PIG EMPIRE

SPECIES: PIG

SPECIAL SKILLS: GIVING ORDERS; FINDING WEAKNESSES

PERSONALITY: LACKS IMAGINATION; EXPECTS TROOPS TO FOLLOW HIM LIKE SHEEP

FORCE FACT
CANIS MAJOR DWARF, THE GALAXY CLOSEST TO THE MILKY WAY, IS 25,000 LIGHT-YEARS AWAY.

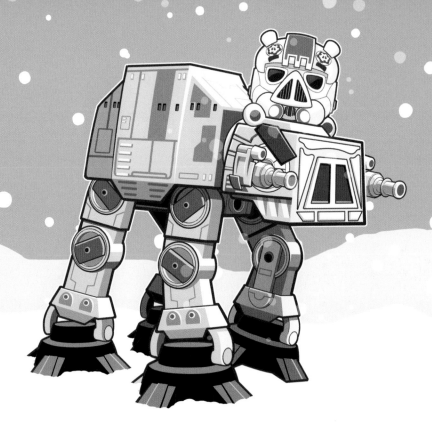

TECH SPECS

NAME: ALL-TERRAIN ARMORED TRANSPORT (AT-AT)

TYPE OF CRAFT: WALKER

WEAPONS: LASER CANNON AND BLASTERS

AFFILIATION: PIGTROOPERS, PIG COMMANDERS

AT-AT WARTIME WALKERS

When the Pig Empire needs to transport lots of troops for an attack, they turn to the All-Terrain Armored Transport, or AT-AT for short. This giant is a metal-plated, mechanical beast that does double duty as troop transport and assault vehicle with formidable laser cannon mounted to its head. Sometimes called a "walker," the vehicle is able to cover any terrain because it can use its four legs to navigate even the most treacherous areas, including the icy snowfields of Planet Hoth.

FROM BIG PIG TO BIGDOG

Most military vehicles that are used to transport supplies don't have legs—they have wheels. But wheeled vehicles have difficulty traversing many different kinds of terrain—mud, snow, sand, and ice can all pose major problems. So engineers at Boston Dynamics have been working on a four-legged, rough-terrain robot they've named BigDog. Not quite as big as the fictional AT-AT, BigDog is about 3 feet (0.9 m) long and 2.5 feet tall (0.75 m) and has a wide range of talents: BigDog can hurl cinder blocks, run at 4 miles an hour (6.4 kph), climb slopes with 35-degree inclines, carry loads of 340 pounds (155 kg), obey simple voice commands, and walk on rubble, mud, and snow. Engineers are hopeful that BigDog's abilities will lead to a robot that can carry the load for soldiers, lightening their burdens in the field.

WHO'S A **GOOD BOY?**

BigDog has an onboard computer that controls the robot's behavior, manages its sensors, and communicates with a remote human operator.

Most of the snow that falls on the planet Mars isn't made of water, but frozen carbon dioxide.

Hoth's icy surfaces are a challenge for the AT-AT walkers.

85

HOTH ASTEROID BELT
COLLISIONS AND CRASHES

SCIENCE FICTION

After the Bird Rebels' defeat on Hoth, the *Mighty Falcon* had to escape from the Pigs' pursuing star destroyers. Ham Solo and Terebacca cleverly maneuvered the *Falcon* into the treacherous Hoth asteroid field, a large area swirling with space rocks of all different sizes. These space rocks are all that remain of two planets that collided billions of years ago. Often these asteroids collide with each other, sending debris spinning off into space and plummeting into planet Hoth as meteorites. The *Falcon* successfully navigated the asteroids and took refuge in a cave on one of the biggest.

SCIENCE FACTS

In the solar system, a similar region exists between Mars and Jupiter. It's called the asteroid belt and is home to hundreds of thousands (perhaps even millions) of space rocks. Unlike what you see in the movies, real asteroids are not packed tightly together. They are spread out with an average of around 1.2 million miles (2 million km) between them. Some spaceships have cruised through the asteroid belt without encountering any space rocks at all. Most asteroids are small and oddly shaped; the smallest have diameters of less than a half mile (1 km). Ceres, the largest one, has actually been classified as a dwarf planet.

ASTEROIDS NAMED AFTER BIRDS INCLUDE CUCULA (THE CUCKOO), BENNU (AN EGYPTIAN BIRD DEITY), AND ARCHAEOPTERYX (THE FIRST KNOWN BIRD).

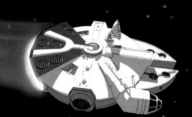

HOTH ASTEROID BELT

CLIMATE: ROCKY AND COLD, WITH VERY LITTLE ATMOSPHERE

NUMBER OF SUNS: 1

NUMBER OF MOONS: 0

POINTS OF INTEREST: SPACE SLUGS; MYNHOGS

Ham Solo pilots the *Mighty Falcon* through the treacherous asteroid field.

FAILED PLANETS

Asteroids were formed during the creation of the solar system over four billion years ago. The planet Jupiter's substantial gravity made it impossible for another world to form between it and Mars. Instead of coalescing into a new planet, the rocky bodies there kept crashing into each other, creating the large debris field observed today. These planetary fragments hold a great deal of information about the early history of the solar system, and scientists are eager to study them more closely. In 2007, NASA launched the Dawn mission, which will visit Ceres and the next largest asteroid, Vesta, to gain more information about the solar system's formation.

CLOSE ENCOUNTERS

The fictional planet Hoth is bombarded by meteorites that have spun off from its asteroid field. Earth has also had its fair share of real encounters with space rocks from the asteroid belt. Collisions in the distant asteroid belt can cause chunks of debris to fly toward Earth. The Earth's atmosphere burns up most of these pieces, but a few do make it to the planet's surface. Space agencies today are monitoring the skies for Near-Earth Objects (NEOs), larger asteroids that pass close to Earth and may even strike it. Stray asteroids have crashed into Earth in the past—one is credited with causing a mass extinction that killed the dinosaurs 65 million years ago. Scientists today are carefully cataloging any NEOs that could be a potential threat and hope to have a complete list by 2020.

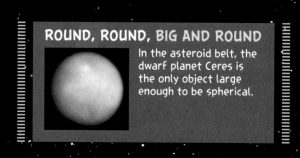

ROUND, ROUND, BIG AND ROUND

In the asteroid belt, the dwarf planet Ceres is the only object large enough to be spherical.

An artist's
depiction of
an impact
on the large
asteroid Pallas

BIGGEST ASTEROIDS

CERES: DISCOVERED IN 1801; 640 MILES (1,030 KM) DIAMETER

VESTA: DISCOVERED IN 1807; 360 MILES (580 KM) DIAMETER

PALLAS: DISCOVERED IN 1802; 335 MILES (540 KM) DIAMETER

HYGIEA: DISCOVERED IN 1849; 270 MILES (430 KM) DIAMETER

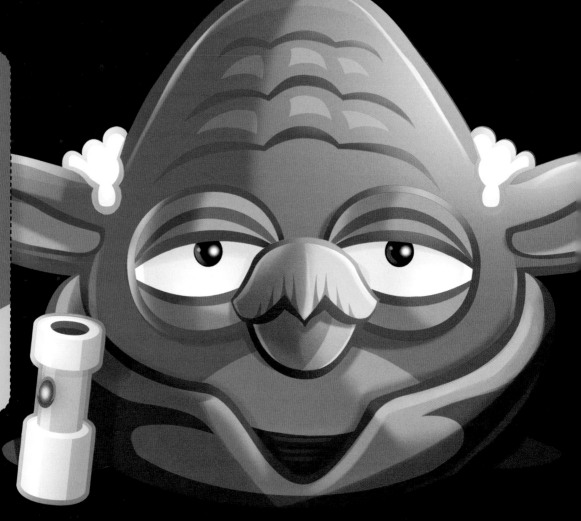

YODA BIRD
THE MASTER OF LIGHT

When Red Skywalker crash-lands on the planet Dagobah, he seeks a Jedi Bird Master. What he finds is a wrinkled old bird who doesn't look a bit like a powerful warrior. But appearances can be deceiving—for this old-timer is Yoda Bird, one of the most powerful Jedi Birds ever. Yoda Bird has hidden himself away from the evil Pigs on Dagobah to protect a powerful secret: the location of The Egg.

COMPLETE THE TRAINING

Yoda Bird agrees to complete Red's training and puts him through a series of demanding exercises. When the time is right, Yoda Bird will share his important secret with Red, but the young bird's impulsiveness often frustrates the old master. In spite of all this, Yoda Bird knows that Red will soon be ready to become a Jedi himself.

YODA BIRD

ALLEGIANCE: JEDI BIRD COUNCIL AND BIRD REBELLION

SPECIES: BIRD

SPECIAL SKILLS: MASTERY OF THE FORCE; SPEAKING IN RIDDLES

PERSONALITY: MYSTERIOUS YET ABSENTMINDED

FORCE FACT
THE PLANET EARTH IS 4.56 BILLION YEARS OLD.

COMBAT REMOTES
FLYING FAST AND FREE

To help Red Skywalker learn to swing a lightsaber, Yoda Bird uses combat remotes as part of the Jedi training. These small, floating spheres are little computers that can be programmed with different combat routines. Small thrusters keep the remotes up in the air and help them to dodge blows while target sensors and laser blasters go on the attack. Red must learn to use his lightsaber to deflect the laser blasts and sharpen his reflexes.

SMART SPHERES

Aboard the International Space Station (ISS) are three flying basketball-shaped robots—used for science, not combat. In 1999, a Massachusetts Institute of Technology professor tasked his students with inventing round floating robots like the ones in *Star Wars*. His team succeeded and named the inventions Synchronized Position Hold, Engage, Reorient, Experimental Satellites, or SPHERES for short. Three SPHERES made it to the ISS in 2006 and have been continually tested and modified to improve operations. Each one has its own power, propulsion, computing, and navigational software. Most recently, smartphones have been incorporated into each one, which gives each robot a built-in camera, sensors, Wi-Fi connection, and improved sensors to conduct inspections. NASA is confident that one day these robots will be able to perform routine maintenance on the ISS and allow astronauts to spend more time on research.

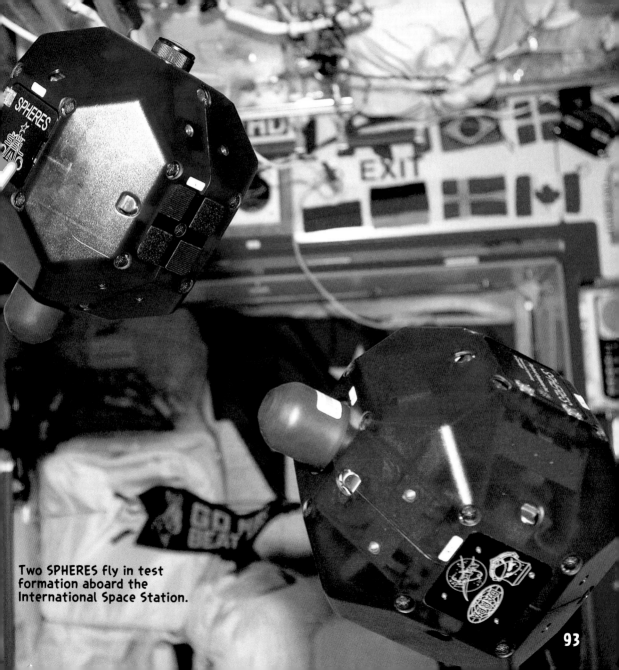

Two SPHERES fly in test
formation aboard the
International Space Station.

DAGOBAH

SCIENCE FICTION

Red Skywalker travels to the mysterious remote planet of Dagobah in search of the great Jedi Master, Yoda Bird. This primitive world is filled with countless shallow lakes, bayous, and swamps. Because of its temperate climate and abundance of liquid water, Dagobah overflows with life—jungles of giant trees and exotic plants and many strange creatures.

WET AND WILD

SCIENCE FACTS

In our solar system, the places most similar to Dagobah are found on Earth. These swampy areas are called wetlands. Found near ocean coastlines and bodies of fresh water, wetlands have soft, marshy soils saturated with water. Lots of wildlife and plants live there; some of the most famous are the Everglades in the United States, the Sundarbans in Bangladesh, and the Okavango Delta in Botswana.

Red Skywalker pilots his X-wing birdfighter to the swampy planet Dagobah.

DAGOBAH

CLIMATE: WET AND MARSHY, WITH LAKES AND INLAND SEAS

NUMBER OF SUNS: 1

NUMBER OF MOONS: 0

POINTS OF INTEREST: YODA BIRD'S HUT

The relative sizes of all the known habitable-zone planets (*left to right:* Kepler-22b, Kepler-69c, Kepler-62e, Kepler-62f, and Earth)

THIS ONE IS JUST RIGHT

Farther away from Earth, scientists are looking for an exoplanet like Dagobah, but it would have to have several things going for it to harbor life. First, it would have to be Earth sized. It would also have to be a rocky or a watery world. And last, it would need to orbit its sun at the proper distance to ensure that it is not too hot and not too cold, but just right for the presence of liquid water; scientists call this location the "circumstellar habitable zone," or more colloquially the "Goldilocks zone." These three conditions, scientists believe, would supply the basic necessities to support life on another planet.

BRAVE NEW WORLDS

Massive space telescopes have been searching the Milky Way for worlds that meet all three criteria, and in April 2013, one of them succeeded. The Kepler space telescope found two roughly Earth-size planets with either rocky or watery compositions that orbit their sun at just the right distance. Named Kepler-62e and -62f, these planets orbit a star that is located 1,200 light-years away from Earth in the constellation Lyra. Kepler-62e is 60 percent larger than Earth and just on the edge of the habitable zone. Kepler-62f is only 40 percent larger than Earth, making it to date the exoplanet closest in size to Earth.

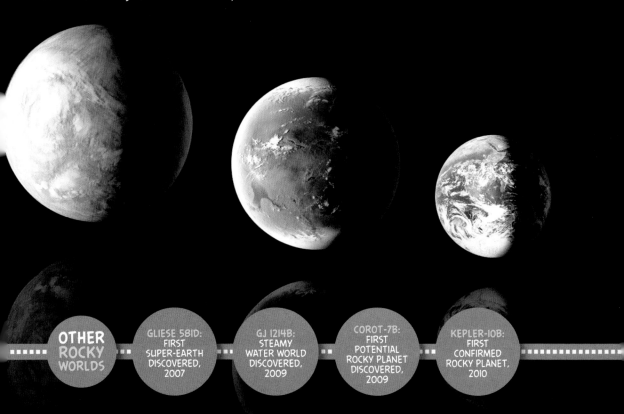

OTHER ROCKY WORLDS

GLIESE 581D: FIRST SUPER-EARTH DISCOVERED, 2007

GJ 1214B: STEAMY WATER WORLD DISCOVERED, 2009

COROT-7B: FIRST POTENTIAL ROCKY PLANET DISCOVERED, 2009

KEPLER-10B: FIRST CONFIRMED ROCKY PLANET, 2010

FORCE FACT

Located in South America, the Pantanal is the world's largest freshwater wetland, covering approximately 68,000 square miles (176,120 sq km).

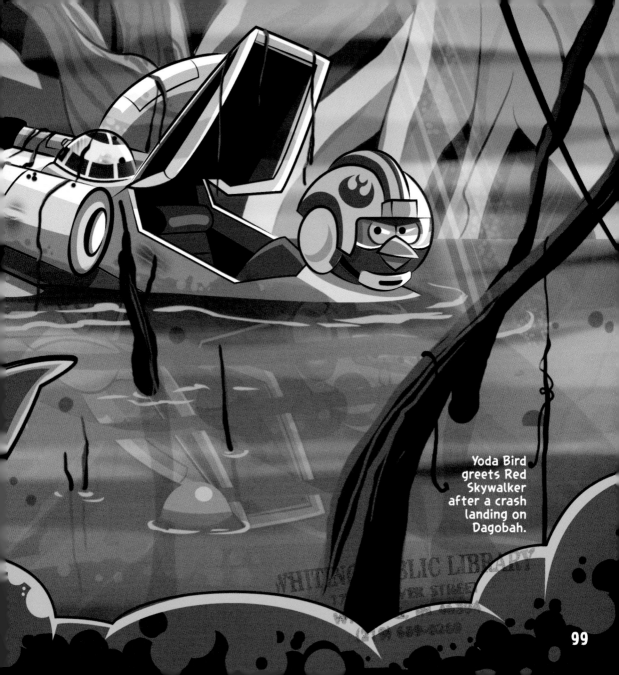

Yoda Bird greets Red Skywalker after a crash landing on Dagobah.

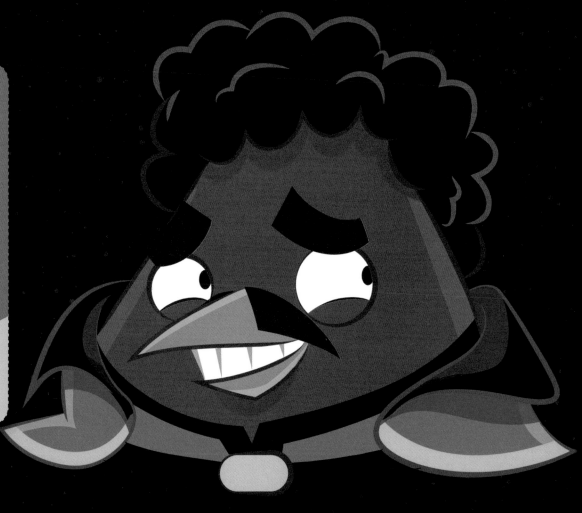

LANDO BIRDISSIAN
THE SMOOTH SQUAWKER

Flying high in Cloud City above the planet Bespin, Lando Birdissian is a smooth-talking charmer. Lando, a former gambler and smuggler, is an old friend of Ham Solo. The two have a long history of losing the *Mighty Falcon* starship to each other in bets.

CON MAN IN THE CLOUDS

As the administrator of Cloud City, Lando gives Ham Solo, Princess Stella, and Terebacca a safe haven when they are on the run from the Pig Empire. After the Bird Rebels land in Cloud City, Solo thinks Lando can be trusted, but Princess Stella is not so sure. She senses that this con bird's smooth squawking is too good to be true.

LANDO BIRDISSIAN

ALLEGIANCE:
BIRD REBELLION

SPECIES: BIRD

SPECIAL SKILLS:
PERSUASION; TALKING

PERSONALITY: A DASHING
ROGUE WITH THE GIFT
OF GAB

FORCE FACT
THE CRAB NEBULA SUPERNOVA EXPLODED ALMOST 1,000 YEARS AGO.

BESPIN
FULL OF HOT AIR

SCIENCE FICTION

The Bird Rebels look for refuge from the Pig Empire in Cloud City, one of the mining colonies on the planet Bespin, a gas giant. Gas giants are typically large planets made of different gases whirling around a small dense core. Bespin is a rare planet, one of the few gas giants in the galaxy that can support life. Despite having no land masses, the planet supports life because of a breathable layer of air in its upper atmosphere. Within this safe haven, or "Life Zone," Cloud City and other floating metropolises could be built among the clouds.

SCIENCE FACTS

In Earth's solar system, the four largest planets—Jupiter, Saturn, Uranus, and Neptune—are gas giants. Unlike Bespin, though, these four gas giants are among the most inhospitable places for life in the solar system. Jupiter's and Saturn's atmospheres are primarily hydrogen and helium gases, while Uranus and Neptune have a mix of hydrogen, helium, and methane. Not only is the "air" in their atmospheres unbreathable, it is also too cold to foster any kind of life in the upper layers. Cold temperatures, high winds, and lack of oxygen make these gas giants unpleasant places to visit.

BESPIN

CLIMATE: TEMPERATE
(IN THE LIFE ZONE)

NUMBER OF SUNS: 1

NUMBER OF MOONS: 2

POINTS OF INTEREST:
CLOUD CITY

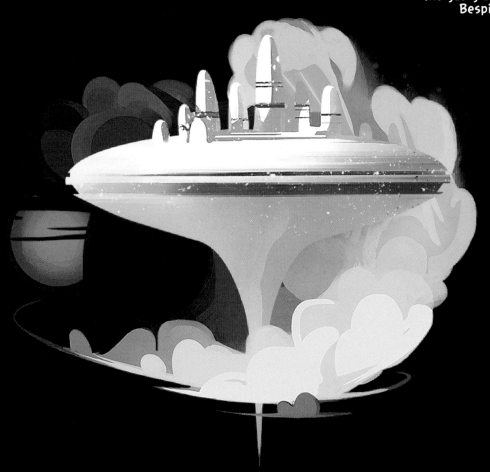

Cloud City floats
in the upper
atmosphere of
the gas giant
Bespin.

MORE THINGS IN HEAVEN AND EARTH

The fictional planet Bespin's ability to harbor life makes it kind of an oddball. But scientists are quickly learning that they've still got a lot to learn about real gas giants in the Milky Way. Gas giants were among the first exoplanets discovered, and many of these early finds blew people away with their strangeness. First, there were the "hot Jupiters," large gas giants whose orbits around their suns are narrower than Mercury's. Finding gas giants so close to their stars was very surprising, and yet there they were. One planet named HAT-P-2b is located about 370 light-years away in the constellation Hercules; its surface temperature rises as high as 3860°F (2127°C) during the day and then falls to 1700°F (927°C) at night.

THE DARKEST SIDE

As more and more gas giants are discovered, stranger and stranger things about them keep emerging. For instance, there's the galaxy's darkest planet, TrES-2b. Located 750 light-years from our solar system, this Jupiter-size gas giant orbits near its star, only about three million miles (five million km) away. The planet's surface gets very hot—1800°F (980°C)—but the planet reflects none of the sunlight that shines on it. Scientists believe that up close the planet would be as black as coal with a slight reddish tinge. Although there are theories, they're not quite sure why TrES-2b is so dark—it could be a whole new class of gas giant.

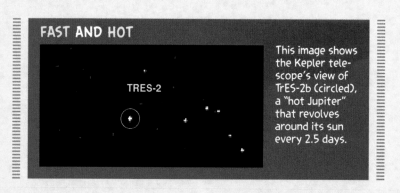

FAST AND HOT

TRES-2

This image shows the Kepler telescope's view of TrES-2b (circled), a "hot Jupiter" that revolves around its sun every 2.5 days.

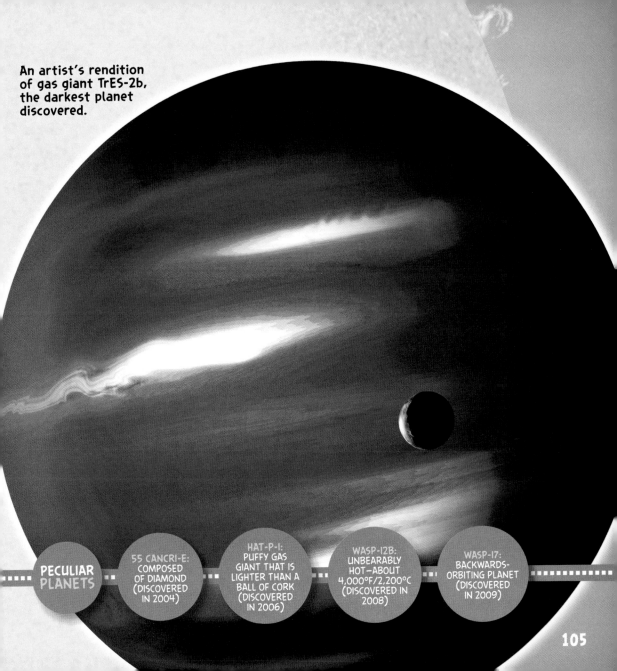

An artist's rendition of gas giant TrES-2b, the darkest planet discovered.

PECULIAR PLANETS

55 CANCRI-E: COMPOSED OF DIAMOND (DISCOVERED IN 2004)

HAT-P-1: PUFFY GAS GIANT THAT IS LIGHTER THAN A BALL OF CORK (DISCOVERED IN 2006)

WASP-12B: UNBEARABLY HOT—ABOUT 4,000°F/2,200°C (DISCOVERED IN 2008)

WASP-17: BACKWARDS-ORBITING PLANET (DISCOVERED IN 2009)

BOBA FATT
THE BOUNTY HUNTER

A Pig of few words, Boba Fatt is a dangerous bounty hunter known for his relentless pursuit of his targets. A true mercenary, Fatt will work for whoever pays him the most, and he has no true loyalty to the Pig Empire—or anybody. His green-and-red armor gives him a menacing appearance, while his jet pack helps him blast from place to place to evade his enemies.

A REBEL AMBUSH

Lard Vader hires Boba Fatt to track down the Bird Rebels. Fatt has a particular interest in Ham Solo, who failed to repay his debts and now has a hefty price on his head. Fatt follows the *Mighty Falcon* to Cloud City and alerts Vader to the Bird Rebels' presence there.

BOBA FATT

ALLEGIANCE: NONE (MERCENARY)

SPECIES: PIG

SPECIAL SKILLS: HUNTING DOWN BIRDS, FOR A PRICE

PERSONALITY: RUTHLESS BOUNTY HUNTER WHO ALWAYS FINDS HIS BIRD

FORCE FACT
GALAXIES LOOK REDDER
THE FARTHER AWAY THEY ARE FROM EARTH.

The Martin
Jetpack in action

BOBA FATT'S JET PACK
ROCKET RIDE

SCIENCE FICTION

Boba Fatt, the ruthless bounty hunter, is known for his distinctive green and red helmet and his rocket-powered jet pack. This Pig flies by using his personal flight system, which is integrated into his armor. When the rockets ignite, the burning fuel creates a thick cloud of exhaust, a perfect smokescreen for an undetected escape. Although powerful, his pack can't fly for long periods of time; it can carry enough fuel for only short bursts of flight.

SCIENCE FACTS

Personal jet packs, like Boba Fatt's, are common gadgets in science fiction stories, but their actual development has been a lot slower than most fans would like. Traditional jet pack design has relied on rockets, which need a lot of heavy hydrogen fuel to lift a person off the ground for as little as 30 seconds. But a new invention, which is still in development, looks more promising. The Martin Jetpack uses gasoline-powered jet engines to power two ducted fans. Gasoline weighs less than rocket fuel, so it does not add as much weight to the whole system. This entire setup can produce enough thrust to lift a person off the ground and keep her in the air for about 30 minutes. Manufacturers anticipate the Martin Jetpack going on sale in 2014, but it will most likely have a hefty $100,000 price tag.

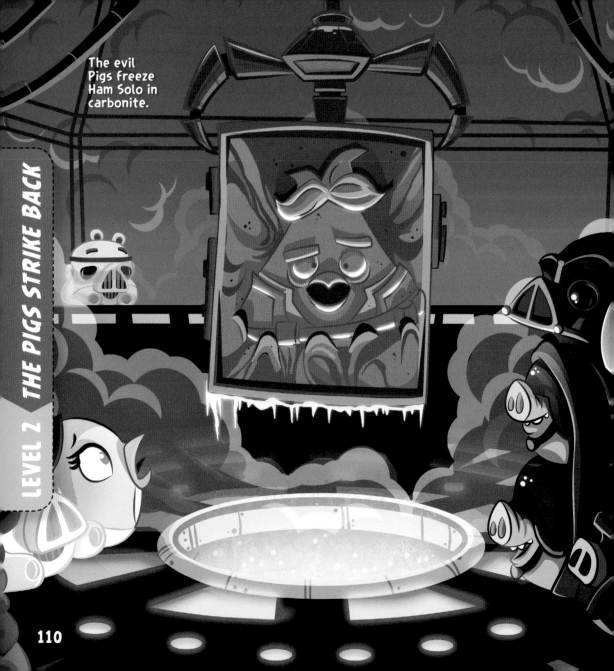

The evil Pigs freeze Ham Solo in carbonite.

CARBON FREEZING
SUSPENDED ANIMATION

After Ham Solo falls into the hands of the Pig Empire in Cloud City, he is frozen in carbonite so the bounty hunter Boba Fatt can take him away on his starship. Carbon freezing is typically used to store the gas that is mined on planet Bespin, but it can also be used on life-forms. After the freezing process, a living creature will go into hibernation until being thawed out later.

DEEP SPACE SLEEP

Space travel takes a long time—in human terms, at least. A one-way trip to Mars would take 6 months; flying to Neptune could take up to 12 years. Scientists are exploring different ways to prepare people for long trips like these, and hibernation may be one method to pass the time. When animals such as bears enter hibernation, their metabolism, breathing, and heart rate are greatly reduced. This state allows them to survive long periods of time when resources are scarce. There

FROZEN FROGS

Native to North America, wood frogs can survive being frozen solid in the winter and thawing out in the spring.

have been notable instances where humans have survived prolonged exposure to the cold by going into hibernation-like states, but people cannot achieve hibernation on demand, yet. Recent studies shows that in certain animals, like lab mice, hydrogen sulfide gas can induce hibernation with no ill aftereffects, but so far the same results have not been produced in people. Scientists hope the gas could one day help humans hibernate on a trip to Neptune, but research is still ongoing.

LEVEL 3

RETURN OF THE RED GUY

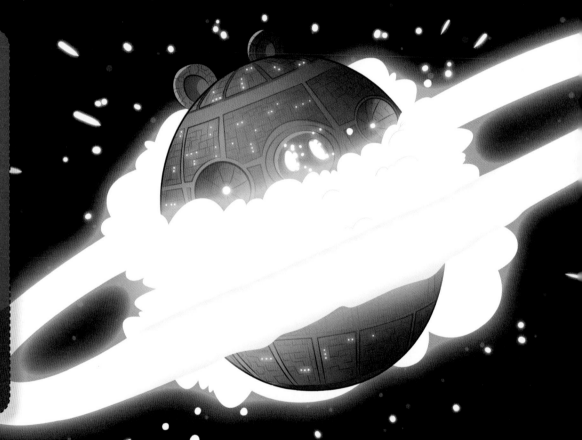

HAM SOLO, frozen in carbonite,
remains in the clutches of the hefty
fiend *JABBA THE HOGG*. But the Bird
Rebels have not given up hope. They
have formulated a plan to infiltrate
Jabba's palace on the planet Tatooine
and rescue their friend. Meanwhile,
the evil EMPEROR PIGLATINE has not
given up his quest to defeat the Bird
Rebels and steal THE EGG so that he
will continue to rule the galaxy. The
PIG EMPIRE has secretly built a new
PIG STAR that could spell doom for
the Bird Rebels' fight for freedom. . . .

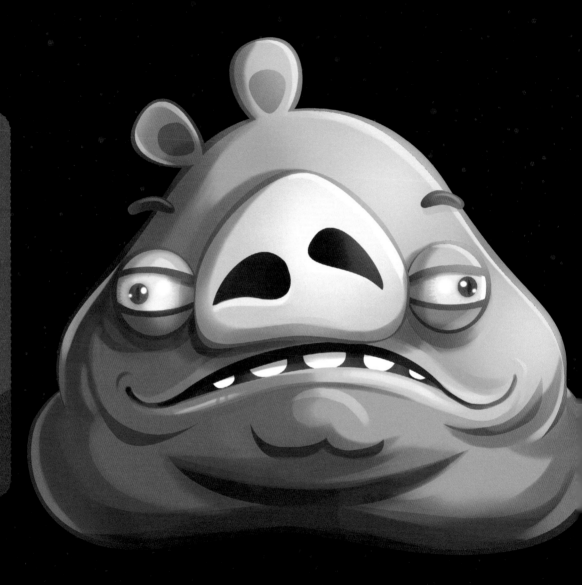

JABBA THE HOGG
THE CRIME LORD

Large, greedy, and ruthless, Jabba the Hogg is one of the galaxy's most feared crime lords. From his desert palace on Tatooine, he and his minions operate a large smuggling ring behind the Pig Empire's back. They gather there to gorge themselves on all kinds of junk food and feast upon their ill-gotten gains.

PALACE REDECORATION

Because Ham Solo owed him a lot of money, Jabba the Hogg had placed a huge price on the cocky smuggler's head. After Boba Fatt delivered the frozen Bird Rebel, Jabba hung Solo on the wall, calling him his favorite decoration. The Bird Rebels have sworn to rescue their friend, but Jabba is not afraid of them. He plans to keep Solo in his evil clutches forever.

JABBA THE HOGG

ALLEGIANCE: **NONE**

SPECIES: **PIG**

SPECIAL SKILLS: **EATING**

PERSONALITY:
A GREEDY CRIMINAL WITH A BOTTOMLESS APPETITE

FORCE FACT
THE EAGLE NEBULA, A REGION OF STAR FORMATION, IS LOCATED IN THE CONSTELLATION SERPENS,

Native to North America, the Common Poorwill is one of the few birds known to hibernate during the winter.

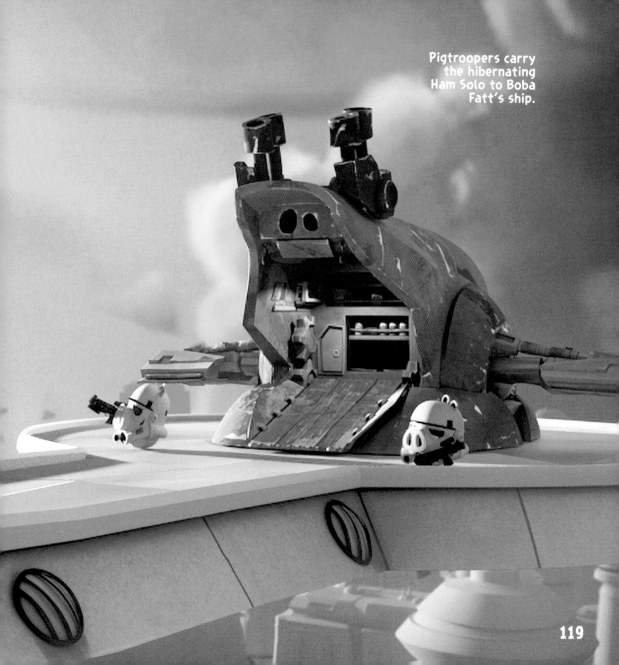

Pigtroopers carry the hibernating Ham Solo to Boba Fatt's ship.

EWOK BIRDS
THE FEATHERED AND FEARLESS

On the forest moon of Endor live the cute little Ewok Birds. Seldom apart, these critters zoom around in big packs among the tall trees of Endor. They adore their woodland home and will do anything to protect it.

NEW ALLIES

The Bird Rebels encounter these creatures when they are searching for the hidden Imperial forces on the moon's surface. The Ewok Birds chirp, chitter, and twitter, but the Bird Rebels can't understand a word they say. But the Bird Rebels know that the little Ewok Birds mean them no harm and are on their side in the fight against the Pigs.

EWOK BIRDS

ALLEGIANCE: BIRD REBELLION

SPECIES: BIRDS

SPECIAL SKILLS: BEING CUTE; LOUD CHIRPING

PERSONALITY: FRIENDLY BIRDS WITH COMMUNICATION ISSUES

FORCE FACT
GIANT REDWOOD TREES TYPICALLY LIVE FOR 500 TO 700 YEARS, BUT SOME HAVE LIVED FOR MORE THAN 2,000 YEARS.

ENDOR
THE FOREST MOON

SCIENCE FICTION

The gas giant Endor has nine natural satellites, the largest of which is a lush, forested world known as the Forest Moon, also simply called Endor. The moon's temperate climate, stable core, and presence of liquid water allow many life-forms to thrive there. The moon is covered with plant life—tall green trees and lush savannas. Many creatures live on Endor, including the Ewok Birds, a species native to this moon, who help the Bird Rebels make a stand against the Pig Empire.

ENDOR

CLIMATE: TEMPERATE
AND HUMID, SUPPORTING
HEAVY FORESTATION

NUMBER OF SUNS: 2

NUMBER OF MOONS: 0

POINTS OF INTEREST:
EWOK BIRD VILLAGE; IMPERIAL
SHIELD GENERATOR

Moons are natural satellites that orbit around larger objects like planets, dwarf planets, and even asteroids. To date, there are 172 known satellites in the solar system orbiting planets, and most planets have at least one. Pluto, now classified as a dwarf planet, has five moons of its own. Some asteroids even have a satellite. However, none of these natural satellites are lush, green worlds teeming with life like Endor. From the outside, they appear to be dead, lifeless rocks.

(FORCE FACT)
VENUS AND MERCURY ARE THE ONLY PLANETS THAT DON'T HAVE MOONS.

The forest moon
of Endor looks
peaceful from above.

LIFE ON THE MOON

But appearances can be deceiving. The real moons in our solar system may not look like Endor, but a few of them are dynamic, active places. Jupiter's moon Io is the most volcanically active body in the solar system. Saturn's moon Titan has liquid methane lakes that rise and fall at different times of the year. And some of these moons are potential sites for alien life. So far, the most promising is Jupiter's moon Europa. Not as big as Earth's Moon, Europa is believed to have an iron core, rocky mantle, and deep ocean of salty water that covers the entire moon.

ICY WATERS RUN DEEP

On the surface, Europa looks frozen solid. Its surface is very cold because it's far from the Sun. But scientists believe that Jupiter's massive gravity heats up the planet by pushing and pulling on the moon's oceans and core. These tidal surges raise and lower the water under the ice, which causes cracks in the surface. It also causes the waters and seafloor to warm up. The pairing of warmer waters with a liquid ocean creates a strong scenario for simple life-forms. On Earth, there are places on the ocean floor where water and rock interact at high temperatures. Called hydrothermal zones, these places are rich with life, and scientists are hopeful that a similar environment could exist on Europa.

EUROPA EXPLORER

Planetary scientist and National Geographic emerging explorer Kevin Hand is spearheading a future mission to send a spacecraft to survey Europa's ice.

Europa's fractured surface is likely hiding an ocean beneath it.

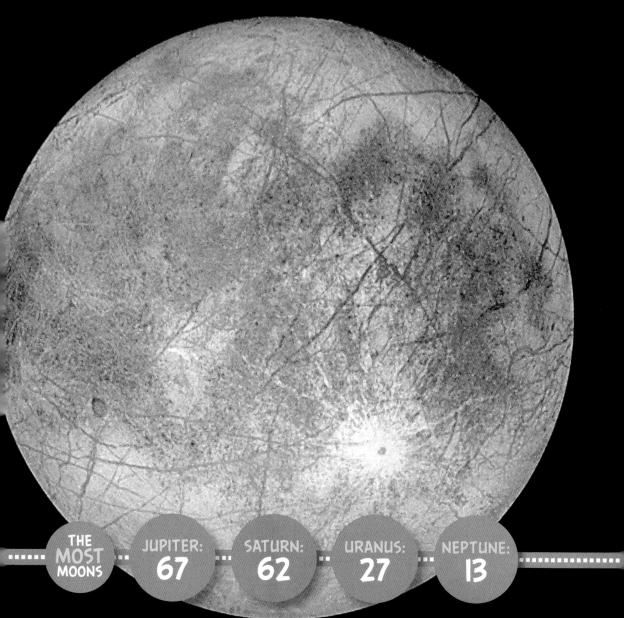

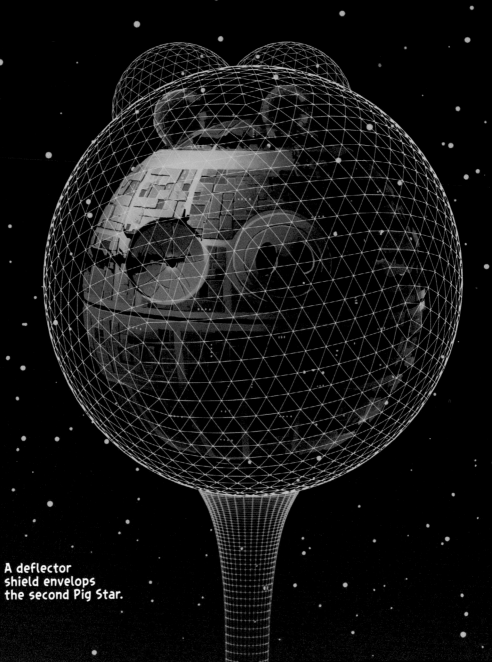

A deflector
shield envelops
the second Pig Star.

DEFLECTOR SHIELDS
TAKE YOUR BEST SHOT

THE PIG STAR WILL BE COMPLETED ON SCHEDULE.

The first deflector shields were developed to protect starships, but Imperial Pig scientists developed one big enough to defend an entire planet or moon. After the destruction of the first Pig Star, the Pig Empire knew it needed a stronger defense for its second mammoth space station. So, it constructed an even larger and more powerful Pig Star with a planetary shield generator that can create a force field to sustain attacks from proton torpedoes and the harmful energy of weapons like lasers and blasters.

MINI MAGNETOSPHERE

Scientists here on Earth are developing deflector shields, too. But these won't be protecting people from lasers—they'll be protecting them from harmful solar radiation and gamma rays. Earth has its own natural deflector shield, the magnetosphere, but astronauts who venture into space are vulnerable to deadly space particles. Using data collected from the Curiosity rover, scientists found that the trip to Mars could expose travelers to radiation levels that exceed NASA's lifetime limit for astronauts. The conclusion is clear: To reach Mars, shields are essential. A British team of scientists with RAL Space may have the answer. They found that a small magnet is able to generate a protective electric field when bombarded with radiation. Now the team is investigating how this finding can work on a larger scale to create deflector shields to protect human pioneers on their way to Mars.

LEVEL 3 RETURN OF THE RED GUY

EMPEROR PIGLATINE
THE MASTER OF EVIL

To be in the presence of Emperor Piglatine is to feel the dark presence of the Pork Side. Evil and greed emanate from this pig, who seeks to dominate the galaxy through fear, displays of power, and massive amounts of junk food. Knowing that Red Skywalker and the Bird Rebels are real threats to him, Piglatine seeks to crush the Bird Rebellion in any way he can.

POWER OF THE PORK SIDE

Together with his evil apprentice Lard Vader (who secretly plots to take the emperor's place), Piglatine rules the Empire with an iron fist as his forces continue to search for The Egg. Whether he will succeed is uncertain, as always in motion is the future.

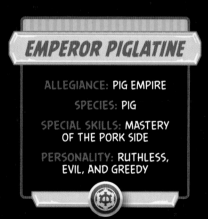

EMPEROR PIGLATINE

ALLEGIANCE: PIG EMPIRE

SPECIES: PIG

SPECIAL SKILLS: MASTERY OF THE PORK SIDE

PERSONALITY: RUTHLESS, EVIL, AND GREEDY

FORCE FACT
THE UNIVERSE IS 13.7 BILLION YEARS OLD.

ALIENS
A MOTLEY CREW

Red Skywalker and Emperor Piglatine look a lot less exotic when compared to the many strange looking aliens living all around the galaxy—from the cantina on Tatooine to the halls of Jabba's palace. There are the big-headed Bith Pigs and the sinister horned Devaronian Pigs. There are the four-eyed Talz Birds and the glassy-eyed Arcona Pigs. These creatures all look different, sound different, and come from different planets with different cultures, customs, and environments, revealing the galaxy's amazing diversity of life.

LIFE ON EARTH

In science fiction, aliens seem to be found on many different planets all over the universe, but in the real world, Earth is the only place with the confirmed presence of life-forms. Humans have been looking for extraterrestrials for a long time. In the 19th century, astronomer Percival Lowell thought patterns on Mars's surface were canals built by Martians (his theory was later disproved). Today, scientists who study the origin, evolution, and distribution of life in the universe, known as astrobiologists, have moved beyond the notion of little green men, but they are still looking for life—from the simplest single-celled creatures to complex, intelligent beings.

Clockwise from upper left: Talz Bird, Arcona Pig, Bith Pigs, Devaronian Pig

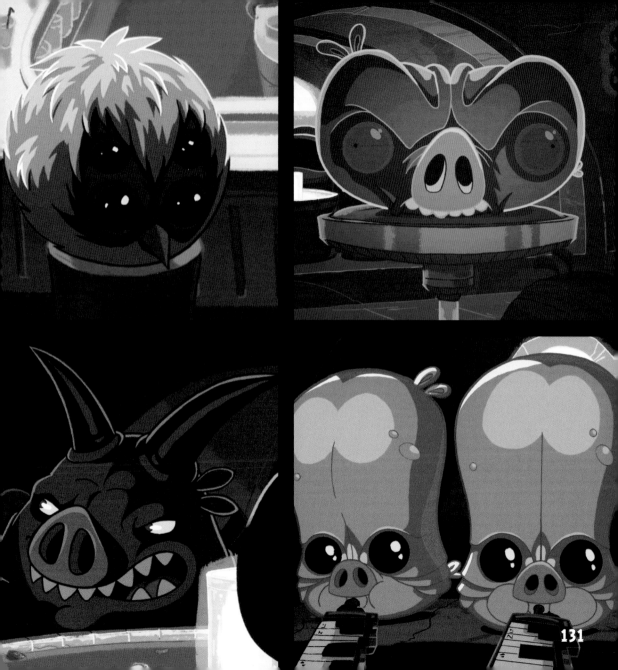

The Allen
Telescope
Array points
skyward
to listen
for signals
from space.

GOING TO EXTREMES

Astrobiologists are often inspired by life-forms here on Earth and the many unexpected places in which they thrive. In the past 50 years, scientists have discovered extremophiles, simple life-forms that are flourishing in some of the hottest, driest, darkest, coldest, saltiest, and most acidic places on Earth. Inside geothermal rocks found in the Norris Geyser Basin in Yellowstone National Park, there are microbes living inside an environment acidic enough to dissolve nails. If simple life-forms can survive in these environments on Earth, then perhaps they can exist in similar places on other planets and moons—like the methane lakes on Saturn's moon Titan or perhaps hydrothermal vents under Europa's subsurface ocean.

LISTENING IN

Astronomers are still searching for more complex forms of life capable of communicating with us, too. SETI, the Search for Extraterrestrial Intelligence, is the scientific field dedicated to this search. The primary technology used today is radio telescopes, like the 42-dish Allen Telescope Array in northern California. The telescopes listen for unusual radio signals from outer space, but so far have heard nothing. Earth has only had its "ears on" for little more than 50 years, though, a minuscule amount of time when considering the vastness and complexity of space. More powerful radio telescope arrays—including the Square Kilometre Array in Australia and South Africa—are being built to continue the search.

THE ULTIMATE SURVIVOR

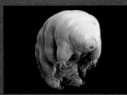

Tardigrades, also called water bears, are extremophiles that can survive just about anything: subzero temperatures, solar winds, and the oxygen-deprived vacuum of space.

BONUS LEVEL | THE FLIGHTLESS MENACE

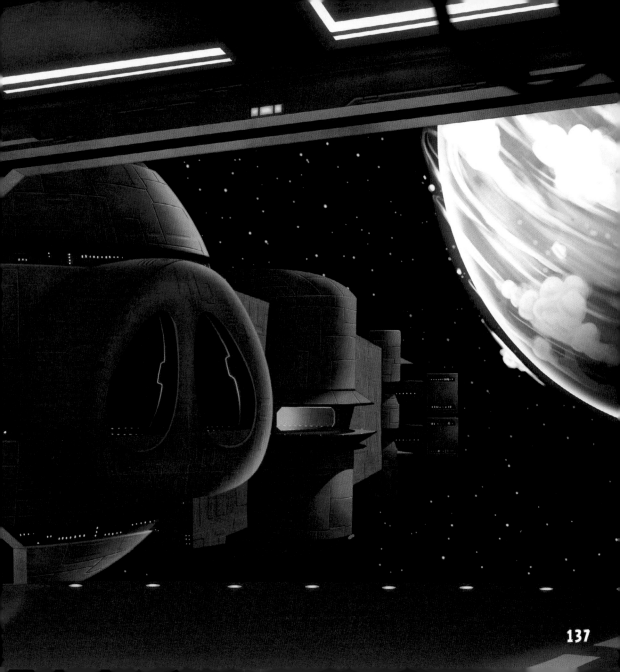

Turmoil has engulfed the galaxy. In
its quest to take over the universe,
the greedy PORK FEDERATION has
threatened the small planet of NABOO
and its peaceful bird inhabitants. To
protect the planet from the PORK SIDE,
the Republic has sent two JEDI BIRD
KNIGHTS to thwart the Pigs' bottomless
appetites for power and junk food. . . .

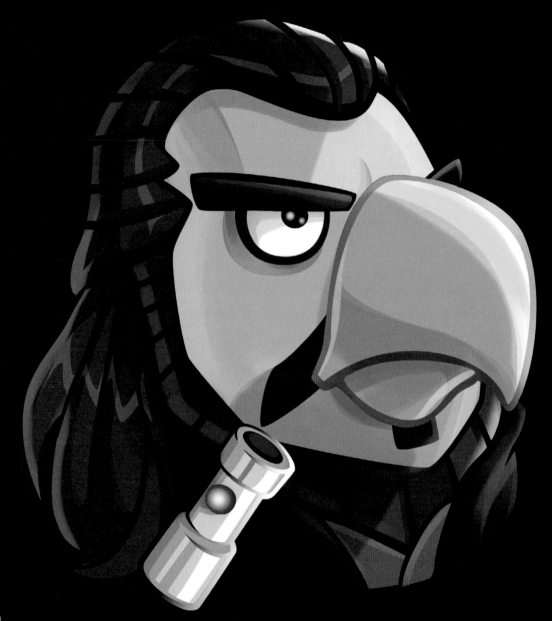

QUAIL-GON
THE MAVERICK

Despite being well trained in Jedi protocol, Quail-Gon is a Jedi Bird Master who follows his own instincts but still retains the respect of his fellow Jedi Birds. A strong mentor, Quail-Gon had trained many Jedi Bird Knights before he took on young Obi-Wan Kaboomi as an apprentice. He and Obi Wan don't always see eye to eye, but they are determined to fight together against the greedy Pigs.

A DARING ESCAPE

The Jedi Bird Council sent Quail-Gon and Obi-Wan Kaboomi to negotiate with the Pork Federation, which is threatening the peaceful planet of Naboo. The Pigs attempted to get rid of the two birds before any conversations began, but the two Jedi Birds escaped to the surface of Naboo, where they must expose the true nature of the Pork Side.

QUAIL-GON

ALLEGIANCE: JEDI BIRD COUNCIL

SPECIES: BIRD

SPECIAL SKILLS: FORCE ATTUNEMENT; LONG-DISTANCE COMMUNICATION

PERSONALITY: MARCHES TO THE BEAT OF HIS OWN DRUMMER

(FORCE FACT)
NEPTUNE'S MOON TRITON IS THE ONLY LARGE SATELLITE THAT ORBITS IN THE OPPOSITE DIRECTION OF ITS PARENT PLANET.

NABOO
A PEACEFUL HAVEN

SCIENCE FICTION

A lush green world of lakes, rivers, sweeping plains, and rolling hills, Naboo is a peaceful world inhabited by two separate civilizations. The planet's surface has been colonized by a group of peaceful birds who are ruled by Queen Peckmé Amidala. These birds live in beautiful cities built near lakes. But deep below the surface are massive underwater caverns and tunnels where the native Gungan birds built their cities. At home on water and land, these creatures evolved on Naboo alongside fantastic and fearsome underwater beasts like the colo claw fish and the sando aqua monster.

[FORCE FACT]
THE OLDEST FOSSILIZED EARTH ANIMAL IS A TINY SPONGE, *OTAVIA ANTIQUA,* FOUND IN A 760-MILLION-YEAR-OLD ROCK.

142

SCIENCE FACTS

The biodiversity of Naboo—both on its surface and underwater—resembles the biodiversity found on planet Earth. But for much of Earth's history, it wasn't a very diverse place. Single-celled bacteria and other simple microorganisms were the dominant life-form on Earth between 3.5 billion and 542 million years ago. Then, for reasons scientists are still exploring, biodiversity on Earth exploded. During the Cambrian period (542-488 million years ago), a bounty of strange, new, complex creatures appeared, including the ancestors of many major groups that exist today like mollusks, arthropods, echinoderms, corals, and sponges. The fossilized remains of these strange underwater creatures often look like the wild creations of science fiction.

NABOO

TERRAIN: SWAMPS, HILLS, PLAINS, AND CITIES

CLIMATE: TEMPERATE

AFFILIATION: GALACTIC BIRD REPUBLIC

NUMBER OF SUNS: 1

NUMBER OF MOONS: 3

POINTS OF INTEREST: THEED (CAPITAL SURFACE CITY); OTOH GUNGA (LARGEST UNDERWATER CITY)

Naboo's temperate climate supports many life-forms.

THE TROUBLE WITH TRILOBITES

The Cambrian period is often referred to as the "Age of the Trilobite," one of the oldest and most successful creatures ever to live on Earth. It is also one of the oddest looking. Emerging in the oceans about 520 million years ago, trilobites look like giant, helmet-wearing bugs (some grew up to 2 feet/0.6 m long!). They had segmented bodies, multiple spindly legs, and hard shells that protected them from predators. After successfully thriving for more than 270 million years, trilobites disappeared from the face of the Earth after an enormous mass extinction event 252 million years ago. But their descendants live on today: trilobites are very distant relatives of horseshoe crabs, spiders, and lobsters.

Tylosaurs were massive reptiles that dominated Earth's ancient seas.

EARTHLY
DEBUTS

450 MILLION
YEARS AGO:
PREHISTORIC

240 MILLION
YEARS AGO:
FIRST

150 MILLION
YEARS AGO:

190,000
YEARS AGO:
FIRST MODERN

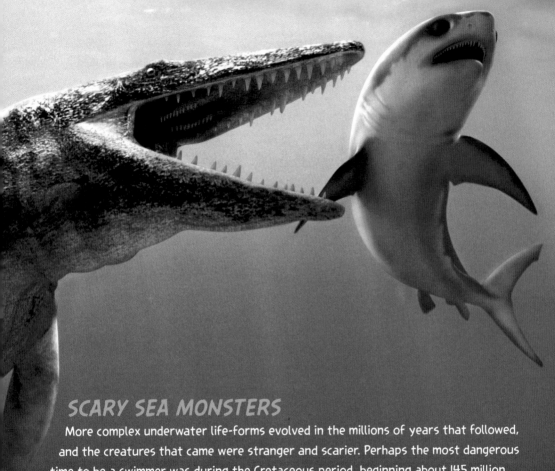

SCARY SEA MONSTERS

More complex underwater life-forms evolved in the millions of years that followed, and the creatures that came were stranger and scarier. Perhaps the most dangerous time to be a swimmer was during the Cretaceous period, beginning about 145 million years ago. Dinosaurs roamed the land, but large marine reptiles and prehistoric sharks ruled the deep. The undisputed top predators were the giant mosasaurs, like the *Tylosaurus*, which grew more than 45 feet (14 m) long. It had jaws full of cone-shaped teeth for catching prey and two extra rows of teeth on the top of its mouth for holding onto it before swallowing it whole. These giant swimmers went extinct when the dinosaurs did, 65 million years ago

REDKIN SKYWALKER

THE PRODIGY

Raised a slave on the desert planet Tatooine, Redkin Skywalker is a young bird who has not lost hope. Good natured and helpful, he lends a helping wing to everyone he can. A master of the mechanical, Redkin can build and repair just about anything. Blessed with lightning-fast reflexes, he is one of the best podracers on the planet and hopes to earn his freedom on the racetrack one day.

A POWERFUL DESTINY

When Redkin first meets Quail-Gon Jinn and Obi-Wan Kaboomi, he wants to be just like the Jedi Bird Knights: strong, just, and powerful. Quail-Gon is impressed by Redkin's abilities, but cautions him to be mindful of his faults. Redkin sometimes lacks patience, and his dreams of becoming a Jedi may cloud his judgment. He will need careful guidance to keep him from the Pork Side.

REDKIN SKYWALKER

ALLEGIANCE: JEDI BIRDS AND BIRD REPUBLIC

SPECIES: BIRD

SPECIAL SKILLS: GOOD WITH MACHINES; EXCELLENT PODRACING PILOT

PERSONALITY: YOUNG, ENTHUSIASTIC, BUT IMPATIENT

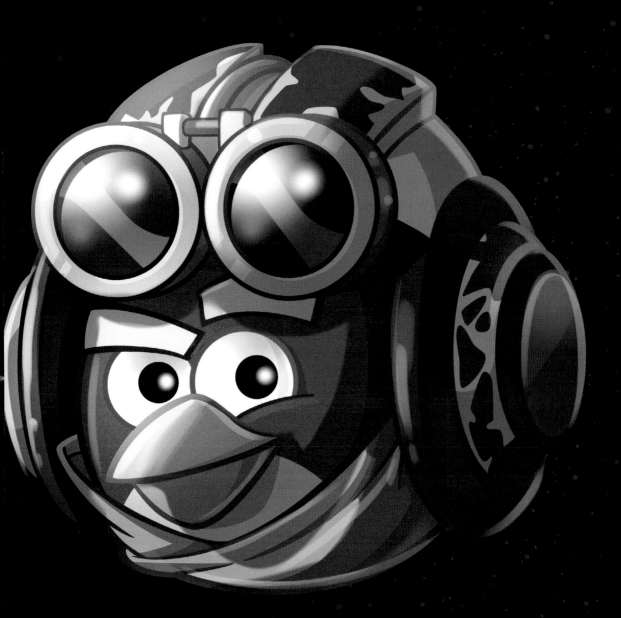

The mobile iRobot 710 can lift and carry heavy objects.

BATTLE PIGS
REMOTE-CONTROL ARMY

The Pork Federation puts its powerful droid army into action during the Battle of Naboo. The army is huge, consisting of thousands of droids. These battle bots lack brains of their own and follow their Pork Side protocol without question. The Battle Pigs are armed with blasters, and a central computer remotely tells them where to fire.

IN THE AIR, ON THE GROUND

Modern military forces are relying more on robot technology to minimize risk to humans in battle situations. Unmanned aerial vehicles (UAV), or drones, are remotely operated planes used for surveillance and targeted strikes without endangering pilots' lives. The U.S. Army is also employing unmanned ground vehicles (UGV), robots on the surface that often scan dangerous areas before soldiers are present. UGVs come in a variety of shapes and sizes, depending on their primary functions. For instance, the large 300-pound (136 kg) iRobot 710 has an arm that can grab and manipulate heavy items weighing up to 350 pounds (159 kg). Then there is the PackBot, a tried-and-true resource in use for more than a decade. Weighing about 40 pounds (18 kg), this small robot is used to neutralize roadside bombs, search damaged buildings, and relay real-time audio and visual data while its operator stays at a safe distance.

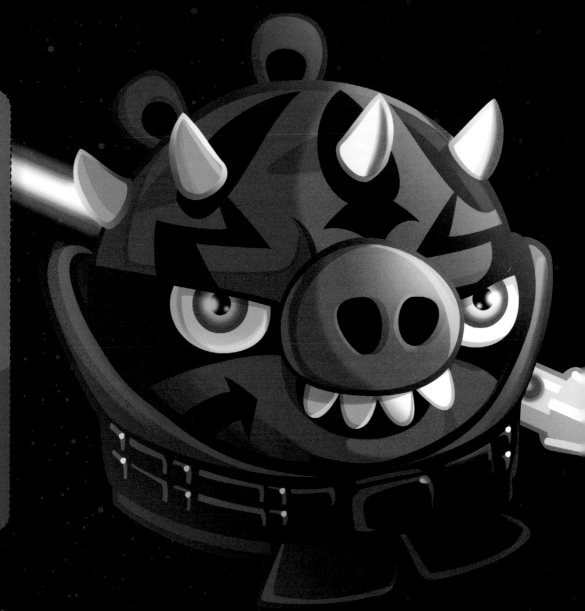

DARTH MOAR
THE EVIL APPRENTICE

Even the bravest birds are afraid when they see Darth Moar. With a tattooed visage crowned by horns, this demented Pig Lord fell to the Pork Side as a piglet. The evil Darth Swindle introduced him to the quick and easy delights of junk food. Their sickeningly sweet flavors overwhelmed the young Moar, who could not resist their appeal and became a student of the Pork Side.

ARE TWO BLADES BETTER THAN ONE?

Moar's weapon of choice is as unique as his face; the red glow of his double-bladed lightsaber strikes fear into the heart of any bird. When Quail-Gon and his apprentice Obi-Wan Kaboomi are trying to protect the planet Naboo and its inhabitants from the Pork Federation, Darth Swindle sends Moar to stop them. Swindle is confident that his apprentice is more than enough Pig to take care of the two Jedi Birds once and for all.

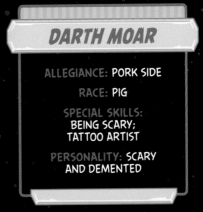

DARTH MOAR

ALLEGIANCE: PORK SIDE

RACE: PIG

SPECIAL SKILLS:
BEING SCARY;
TATTOO ARTIST

PERSONALITY: SCARY
AND DEMENTED

Further Resources

Angry Birds *Star Wars* Websites

Angry Birds *Star Wars*: Official website of the game Angry Birds *Star Wars*. Features fan art, video trailers, and the latest news about the game.
http://angrybirds.tumblr.com

Astronomy Websites

European Space Agency: Official website of the European Space Agency.
http://www.esa.int

Extrasolar Planets Encyclopaedia: Website that tracks all the confirmed exoplanets discovered to date.
http://exoplanet.eu

International Astronomical Union: Official website of the international confederation that promotes the study of astronomy.
http://www.iau.org

Kepler Mission: Official website of NASA's planet-hunting Kepler Mission.
http://kepler.nasa.gov

Minor Planet Center: Website with a complete listing of all the names and numbers of minor planets in the solar system.
http://www.minorplanetcenter.net/iau/lists/MPNames.html

NASA: Official website of the National Aeronautics and Space Administration.
http://www.nasa.gov

NASA Exoplanet Archive: Website with the latest and historic information of exoplanet candidates and confirmed discoveries.
http://exoplanetarchive.ipac.caltech.edu

Planetary Society: Official website of an American nonprofit group dedicated to space exploration.
http://www.planetary.org

SETI Institute: Official website of an American institute dedicated to the search for intelligent life in the universe.
http://www.seti.org

Square Kilometre Array: Official website for what will be the largest and most sensitive radio telescope, built on one total square kilometer in Australia and South Africa.
http://www.skatelescope.org

Robotics Websites

Carnegie Mellon Robotics Institute: Official website of the robotics program at Carnegie Mellon University, home of HERB, the Home Exploring Robot Butler.
http://www.ri.cmu.edu

NASA Robotics: Official website of the Robotics Alliance Project.
http://robotics.nasa.gov

Books

Briggs, Amy. *National Geographic Angry Birds Space: A Furious Flight Into the Final Frontier.* Washington, D.C.: National Geographic Society, 2012.

National Geographic Atlas of the World, 9th Edition. Washington, D.C.: National Geographic Society, 2010.

The Science Book: Everything You Need to Know About the World and How It Works. Washington, D.C.: National Geographic Society, 2008.

Trefil, James. *Space Atlas: Mapping the Universe and Beyond.* Washington, D.C.: National Geographic Society, 2012.

Weapon: A Visual History of Arms and Armor. New York: DK Publishing, 2010.

About the Author

When Amy Briggs isn't watching *Star Wars* movies or playing Angry Birds, she's often writing books. *National Geographic Angry Birds Star Wars* is the third in her personal trilogy of Angry Birds game companions, which also includes *National Geographic Angry Birds Space* and the forthcoming *National Geographic Angry Birds Seasons.* A former senior editor with National Geographic Books, Briggs contributes regularly to National Geographic Daily News' "Tales of the Weird" blog. Her writings can also be found at her own blog Briggs in Space, (briggsinspace.wordpress.com), where she writes about the trivial, the strange, and the just plain cool. Briggs lives in Virginia with her husband, her daughter, and two gray cats.

Glossary

Asteroid Belt: a region in the solar system between Mars and Jupiter where a large group of small, rocky bodies revolve around the sun.

Astrobiology: the study of the origins, evolution, distribution, and future of life in the universe. This field includes the search for extraterrestrial life in the solar system as well as on habitable planets outside the solar system.

Astronomical Unit (AU): the average distance between Earth and the Sun, about 93 million miles (150 million km), used primarily to measure how far apart objects are in the solar system.

Atmosphere: a layer of gases enveloping a planet or other large astronomical object with enough gravity to hold it in place.

Binary Star: a star system consisting of two stars orbiting around a common center of mass. The brighter star is called the primary, and the other is its companion.

Desert: a place on Earth that receives less than 10 inches (25 cm) of rain per year. The Sahara is the largest hot desert in the world, and Antarctica is the largest cold desert.

Dwarf Planet: an object orbiting a sun that is large enough to be spherical but has not cleared all objects from its orbital paths. In the solar system, Ceres, Eris, Haumea, Makemake, and Pluto are classified as dwarf planets.

Evolution: the changes that occur over time in a population of organisms as different genetic traits are passed down through successive generations.

Exoplanet: a planet orbiting a star or stars other than the Sun.

Extremophile: an organism that can live in extreme environmental conditions.

Galaxy: a collection of billions of stars held together by their mutual gravity.

Gamma Rays: waves of light that are generated by radioactive atoms and in nuclear explosions. Gamma rays can kill living cells.

Gas Giant: a large, low-density planet composed primarily of hydrogen and helium; in the solar system, Jupiter, Saturn, Uranus, and Neptune are classified as gas giants.

Gravity: the attractive force that every object in the universe—from small atoms to giant planets—has on other objects.

Habitable Zone: the orbital distance from a star where water can exist as a liquid on the planet's surface; also called the "Goldilocks zone."

Hibernation: an extended period of deep sleep in which animals reduce their metabolic rates and lower their body temperatures to survive time periods when resources are extremely scarce.

Hovercraft: a vehicle capable of traveling over land, water, and ice by floating on a cushion of air created by downwardly directed fans.

International Space Station: a habitable space station in orbit over Earth. The largest object humans have put into orbit, it doubles as a laboratory for new technologies and an observation platform for astronomical, environmental, and geological research.

Interstellar Space: the region between stars.

Ionic Propulsion Engines: engines that harness magnetic fields, instead of depending on chemical explosions, to create thrust.

Kepler Mission: the search for habitable exoplanets and an exploration of the structure and diversity of other planetary systems and stars, using the Kepler telescope to survey one small area of the Milky Way.

Lander: a spacecraft that travels to, descends toward, and collects data from another planet, asteroid, or satellite. Some landers are meant to land softly on the surface, while others, called impactors, are designed to crash into it.

Light-year: a unit of distance equal to the distance light travels in a vacuum in one year, or about 6 trillion miles (9.5 trillion km), used to measure the distance between astronomical objects.

Meteor: the streak of light seen in the sky when an object, or "meteoroid," enters and burns up in the Earth's atmosphere; often called a "shooting star" because it appears as a streak of light in the night sky.

Meteorite: a piece of space debris (typically from an asteroid or comet) that travels through the Earth's atmosphere and makes it to the planet's surface.

Milky Way: a large spiral galaxy that contains more than 200 billion stars and is home to Earth and the solar system.

Mir: a modular space station that orbited Earth from 1986 to 2001. Operated by the Soviet Union and later by Russia, the station was the first to be consistently occupied by research crews performing experiments in astronomy, biology, physics, and the effects of microgravity and life in space on people.

Moon: a natural satellite in orbit around a planet, dwarf planet, or asteroid.

Near-Earth Object (NEO): an asteroid whose orbit brings it into Earth's orbital area, where it could possibly collide with the planet.

Orbit: the path followed by an object moving in the gravitational field of a larger object, such as the path of a planet around a star or a moon around a planet.

Orbiter: a spacecraft that travels to and orbits around another planet, asteroid, or satellite to collect scientific data.

Parsec: an astronomical measure of large distances, such as between objects in the Milky Way. One parsec equals 3.26 light-years.

Planet: a body in orbit around the sun with enough gravity to hold a spherical shape that has cleared its path of other large bodies, other than its satellites.

Rocky Planet: a planet made of rocks and heavy metals, with a hard surface and a heavy metallic core; also called a "terrestrial planet." Mercury, Venus, Earth, and Mars are the solar system's rocky planets.

Rover: a wheeled spacecraft that is able to travel to, land on, and move around the surface of another planet, asteroid, or satellite.

Solar Flare: a sudden and intense outburst of the lower layers of the sun's atmosphere.

Solar Panel: a group of photovoltaic cells that collect and convert light into electricity.

Solar Radiation: electromagnetic energy emitted by the sun, including visible, ultraviolet, and infrared light.

Star: a giant ball of luminous gases held together by gravity. The sun is the closest star to Earth.

MYNHOG

Angry Birds *Star Wars* Terms

All-Terrain Armored Transport (AT-AT): a massive four-legged transport and assault vehicle; often called a "walker."

Astromech Droids: droids that specialize in starship maintenance, repair, and navigation.

Bird Rebellion: a group of angry Bird Rebels who are fighting to save the galaxy from the forces of the evil Pig Empire.

Blaster: a common weapon that fires energy bolts against targets. They range in size from handheld weapons to larger cannon.

Bounty Hunters: mercenaries who take money to track down and capture birds with prices on their heads.

Combat Remotes: floating computerized spheres programmed to train Red Skywalker in lightsaber combat.

Deflector Shields: force fields that can repulse energy and physical attacks, used to defend large objects, like the Pig Star, or smaller things, like starships.

The Egg: a mysterious hidden relic which contains the Force—the power to rule the galaxy.

Hyperdrive: an engine that allows starships to travel above the speed of light.

Jedi Bird Knights: the traditional protectors of freedom and justice in the galaxy.

Landspeeder: a small transport vehicle with engines that lift it up so it floats over the ground.

Lightsaber: a sword with a blade of pure energy, capable of cutting through most materials, except other lightsabers; carried by Jedi Birds and Sith Lards.

Mynhogs: winged, cave-dwelling, pig-faced creatures that dwell on the asteroids near the planet Hoth and have the ability to suck power from spaceships.

Pig Empire: an evil group of greedy, junk-food-swilling pigs intent on controlling the entire galaxy. Led by Lard Vader and Emperor Piglatine, they search everywhere for the all-powerful Egg.

Pig Star: the Pig Empire's giant space station used to house Pigtroopers, TIE fighters, and junk food.

Probe Droid (Probot): a reconnaissance droid sent to locations around the galaxy to collect data and transmit it back to the Pig Empire.

Protocol Droid: a droid programmed to understand alien languages, manners, and diplomacy.

Sith Lards: pigs devoted to the Pork Side and to consuming all the junk food in the galaxy.

TIE Fighter: a fast-moving, solar-powered starfighter used by the Pig Empire.

X-wing Birdfighter: a versatile starship that serves as both starfighter and interplanetary transport.

MYNHOG

Illustration Credits

8-9, NASA/JPL-Caltech/ESA/Harvard-Smithsonian CfA; 22, NASA/Kepler Mission/Wendy Stenzel; 22-23, NASA/JPL-Caltech/R. Hurt; 27 (Robot), Jason Campbell/Robotics Institute/Carnegie Mellon University. CMU's HERB robot is supported by the National Science Foundation, Quality of Life Technology Center under Grant No. EEEC-0540865; (Polka Dot Background), Rodin Anton/Shutterstock; 31, Energetic Materials and Products, Inc (EMPI); 33, Larry Bartholomew/Aerofex Corporation; 39, U.S. Navy, Official Photograph; 42, NASA; 43, NASA/Photo Courtesy SpaceX; 47 (LE), Neil A. Armstrong/NASA; 47 (CTR), NASA; 47 (RT), NASA; 50, NASA; 50-1, NASA; 57, NASA/JPL-Caltech; 61, DoD photo by Sgt. Tammy K. Hineline/U.S. Marine Corps, Official Photograph; 63, Jean Revillard/Rezo/Solar Impulse/Polaris; 71, Courtesy of the University of St. Andrews; 74, NASA/JPL/Space Science Institute; 74-75, NASA/JPL/Space Science Institute; 77, NASA/JPL-Caltech; 78-9, Rover model by Dan Maas; synthetic image by Koji Kuramura, Zareh Gorjian, Mike Stetson and Eric M. De Jong/NASA/JPL/Cornell; 83, Boston Dynamics; 88, NASA/ESA/SWRI/Cornell University/University of Maryland/STSci; 88-89, UCLA; B. E. Schmidt and S. C. Radcliffe; 93, NASA; 96-97, NASA Ames/JPL-Caltech; 104, NASA/Ames/JPL-Caltech; 104-105, David A. Aguilar (CfA), TrES, Kepler, NASA; 108, Martin JetPack; 111, Joel Sartore/National Geographic Creative; 124, Kevin Hand; 125, Science Source; 126, Grids based on Pavel Ignatov/Shutterstock and Nesta/Shutterstock; 132-133, Seth Shostak/SETI; 133, Science Picture Co./Corbis; 144-145, Matte FX Inc./NGS; 148 (Robot), iRobot; (Sky Background), ekina/Shutterstock; (Rocks), Val Lawless/Shutterstock.

Acknowledgments

We would like to extend our thanks to the terrific team who worked so hard to make this project come together so quickly and so well.

Lucasfilm Carol Roeder, Joanne Chan Taylor, Troy Alders, Leland Chee, Hez Chorba, Lee Jacobson, Tina Mills, and Shahana Alam

Rovio Sanna Lukander, Laura Nevanlinna, Nita Ukkonen, Jan Schulte-Tigges, Toni Kysenius, Alberto Camara, and Jarrod Gecek

National Geographic Bridget A. English, Jonathan Halling, Dana Chivvis, Ben Shannon, George Bounelis, Galen Young, Judith Klein, Marshall Kiker, and Lisa A. Walker

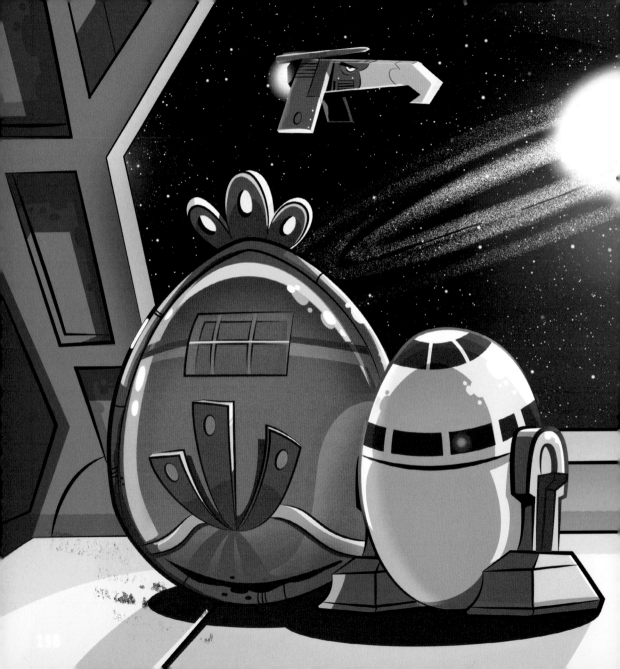

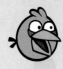
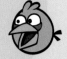